Applying Visual
Thinking in your
day-to-day
business

VISUAL
DOING

Get your free
visual doing
worksheet here!

burobrand.nl/worksheet

Buro BRAND

Den Haag, The Netherlands

info@burobrand.nl

www.burobrand.nl

Author Willemien Brand

with essential input from:

Georgette Pars

Hester Naaktgeboren

Inge de Fluiter

Laut Rosenbaum

BIS Publishers

Building Het Sieraad

Postjesweg 1, 1057 DT Amsterdam, The Netherlands

T +31 (0)20 515 02 30

bis@bispublishers.com

www.bispublishers.com

ISBN 978 90 6369 499 9

VISUAL DOING

Applying Visual Thinking in your day-to-day business

Willemien Brand

BISPUBLISHERS

VISUAL DOING
CONTENTS ROADMAP

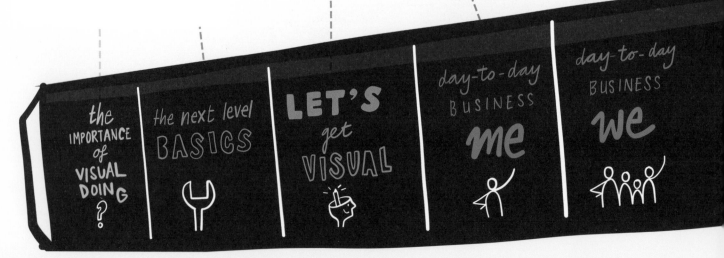

the IMPORTANCE of VISUAL DOING?

the next level BASICS

LET'S get VISUAL

day-to-day BUSINESS me

day-to-day BUSINESS we

6

7 ♬ yes!

LET's Do VISUAL

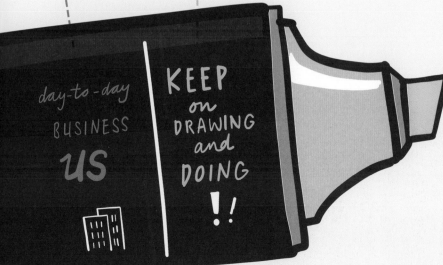

day-to-day BUSINESS US

KEEP on DRAWING and DOING !!

TABLE OF CONTENTS

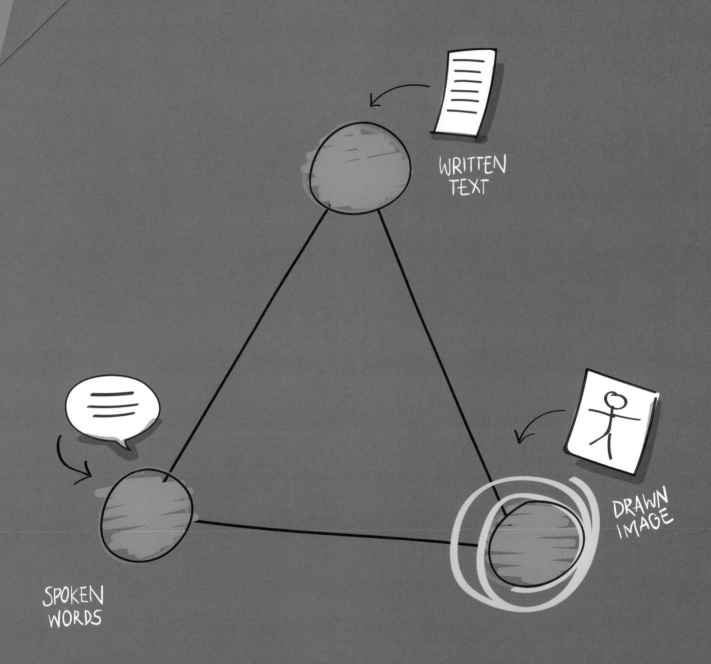

WRITTEN TEXT

SPOKEN WORDS

DRAWN IMAGE

TRIANGLE of
EFFECTIVE COMMUNICATION

1. THE IMPORTANCE OF VISUAL DOING

It is incredibly inspiring to see how the Visual Thinking community is spreading around the world. This book guides you step-by-step down the path to transforming Visual Thinking into DOING!

Visual thinking and doing strengthens communication on so many levels. Your story will resonate more deeply with audiences. It enables co-creation and increases energy in meetings. But most of all it's a lot more fun. Drawing visuals helps you explain yourself and to clearly convey messages.

Drawing is a way of life to me. Visualizing processes to clarify and explain them comes so naturally to me; it has become my inner drive. I love helping people to learn this powerful tool and make it as natural for them as speaking and writing. Anytime. Anywhere.

People enjoy discovering how easy it is to use drawings in business settings. We enjoy taking them on that journey of discovery. This book will satisfy in a very simple way your desire to communicate visually. Broken down into ready-to-use tips and tools, it helps improve your drawings and broaden your skillset and empowers you to tell your own visual stories.

It has been a great pleasure writing and drawing this book together with my highly appreciated partners Inge de Fluiter, inspirational visual interpreter and canvas designer, and Laut Rosenbaum, creative strategist and visual story telling trainer. And, of course, my colleagues Hester Naaktgeboren and Georgette Pars, driven and passionate designers and Visual Thinkers.

Together, we have both enriched and simplified our first book, Visual Thinking, to create a practical guide that will empower you to start DOING more and improve your visual craftsmanship.

Willemien Brand, Founder of Buro BRAND.

THE STRUCTURE OF THIS BOOK

This book is both a sequel to Visual Thinking and a whole new book in its own right. We introduce new skills, tips and tools and challenge you to DO VISUAL.

We start with the basic skills. Chapter 2 is a bit more theoretical and teaches you about composition, visual hierarchy and metaphors. A must-read chapter! Chapter 3 makes clear that you can draw ANYTHING you want. It gives examples to help you build your own visuals library with typography, a lot of icons, combi-nations of icons and more. After these chapters, part 2 of the book begins. With chapters 4, 5 and 6, respectively, dealing with:

- **'Me as an individual'**
- **'We as a team'**
- **'Us as a company'**

In ME and WE, we'll cover visual working forms we love. From a heart-to-heart conversation to co-creating a roadmap. In US, we elaborate on these visual work-ing forms. We highlight cases where our visual work forms have helped organizations to trans-form their structures and commu-nications. We finish up with some tips to make sure you continue drawing long after you've read this book.

VISUAL THINKING VS. VISUAL DOING

Our first book, Visual Thinking, fo-cusses on drawing skills to make you believe and experience that you CAN draw!

It breaks down barriers, gives you simple and effective exam-ples and tips and starts changing your mindset into that of a Visual Thinker.

In this book, Visual Doing, we take things to the next level. We em-phasize how best to communicate with your drawing and we focus on how to apply visual thinking in your own work, in team and group settings and - on a larger scale - in organizations.

In today's swiftly changing busi-ness environment, agility is vital. We hear terms like scrum, lean-startup and design thinking. Visual thinking is key to these modern ways of working and this book can help you master it.

Packed with inspirational ideas, Visual Doing picks up where Visu-al Thinking left off.

BAD EXCUSES FOR NOT DOING VISUAL

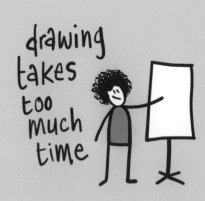

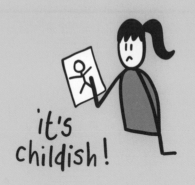

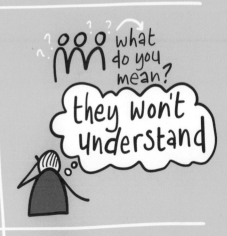

YOUR HOW, OUR WHY

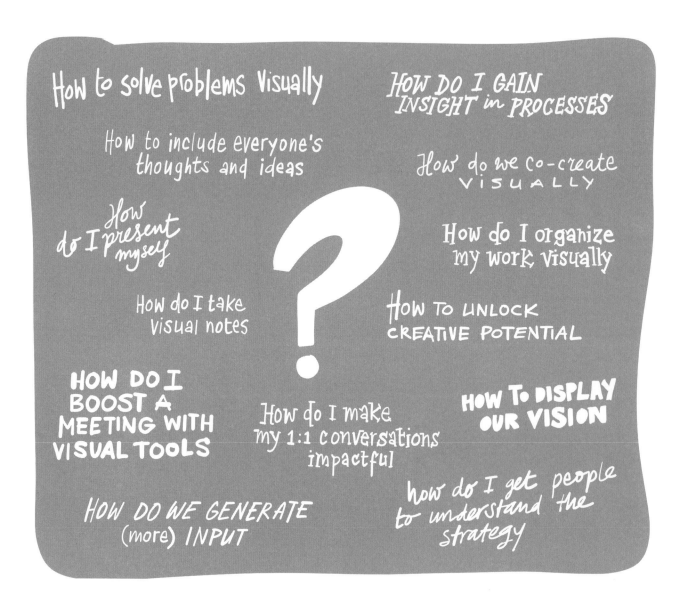

How to solve problems visually

HOW DO I GAIN INSIGHT in PROCESSES

How to include everyone's thoughts and ideas

How do we co-create VISUALLY

How do I present myself

How do I organize my work visually

How do I take visual notes

HOW TO UNLOCK CREATIVE POTENTIAL

HOW DO I BOOST A MEETING WITH VISUAL TOOLS

How do I make my 1:1 conversations impactful

HOW TO DISPLAY OUR VISION

HOW DO WE GENERATE (more) INPUT

how do I get people to understand the strategy

We hear it a lot: You feel and see the power of visual thinking all around you, but wonder: How do I start?! This book tackles those 'how' questions for you.

We have a passion for making things easy and understandable to everyone. Step by step we will guide you through a range of visual working forms by using inspiring examples and cases.

WHY WORK VISUALLY?

We process a dizzying array of visual information every day! Advertising, social media, infographics, signage; we live in an age of visual information overload. At work we use visuals mostly in the form of infographics, pie charts, diagrams or (Powerpoint) presentations.

With the increase in (visual) stimuli and the decrease of attention spans, you need to do more to not only communicate but really deliver your message. If you want to grab your audience's attention, it is no longer enough to simply present them dry data that appeals the head.

You have to do more: You also have to touch their hearts! To win over the hearts and minds of your audience, you need to present clear information in such a visual way that it oozes creativity, conviction and passion. A passionate presentation with great visuals will touch an audience in a way a 100-page report never will.

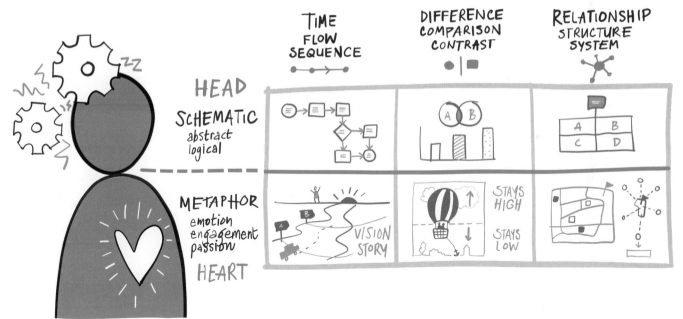

Working visually can be the right choice for so many more reasons! See the next (yellow) pages to get a glimpse of some of them.

the IMPACT of WORKING VISUALLY

OPENS THE MIND TO DIFFERENT POSSIBILITIES

ALIGNMENT

MAKES PROCESSES CLEAR

UNCOVER OTHER OUTCOMES

it's TANGIBLE

NEW IDEAS BETTER INSIGHTS

CREATE A HIGH PERFORMING TEAM

APPROACHABLE

EASY FOR PROTOTYPING

ACCELERATE BUSINESS

INVITES PEOPLE
TO DISCUSS &
CRITICIZE

BUILDING TOGETHER

COMMUNICATE
FASTER

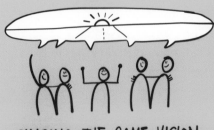

SHARING THE SAME VISION

ENERGIZES

IT
REACHES
THE HEART

FUN!

EXPRESS
YOUR
CREATIVITY

TO THE POINT

IT ENGAGES
TO SHARE,
TO TELL

IT SIMPLIFIES

KICK
STARTS
CHANGE

MATERIALS

Okay, you're ready for this! You bought the book(s) and have the good intentions, but which materials do you need to make a good start?

Paper
- The real must-have; a big old roll of brown paper! A great base for strategy walls, roadmaps, or other visual adventures.
- Big sheets of white paper or flipchart sheets.
- A stack of A3 sheets, because we think A4 is too small for your artwork.
- If you're going to be brainstorming or mapping content or elements, sticky notes or small blank papers are unmissable.

Tip: You can also use rolls of cheap wallpaper, wrapping paper and even paper table cloths and place mats from restaurants. Make the most of your supplies by using both sides of brown paper sheets and flip charts. And you can recycle brown paper by using it to wrap gifts!

Sticky notes nowadays are available in loads of colors, shapes and sizes! They even have black (which we love in combination with a white paint marker). Beware of too intense or bright color(-combinations) and don't forget to pull the post-it off the stack from the side (not the bottom), to avoid it curling up on the wall.

Flipchart markers
We love Neuland markers, they are refillable and don't leak through your paper. We especially love the Big One for when your work really needs to be visible! We recently found a new Japanese brush pen which we love. Keep exploring until you you've found a marker set that suits you and matches your handwriting.

Paintmarker
Molotov, Posca and other brands offer acrylic paint markers which are great on brown paper or dark backgrounds.

Storage
A nice pencil case is essential to store you markers. Are you drawing often? Buy an apron or toolbelt to be more mobile when drawing on location.

Whiteboard markers
Whiteboard markers are the most underestimated markers there are! Start by throwing out all the usual green, red and blue primary colors with rounded points and buy a nice color range (e.g. your company colors) with a chisel tip. Variation in thick and thin lines will make way more impact.

Digital
Of course you can draw digitally as well. We love an iPad and Apple Pencil in combination with our favorite apps. Check out our recommendations in chapter 7.

Make sure you have enough stock so material won't be a deal-breaker on your visual journey. But if you do run short, you should never allow yourself to be held back by the lack of right materials: If nothing else is available you can even simply draw with your finger in the sand.

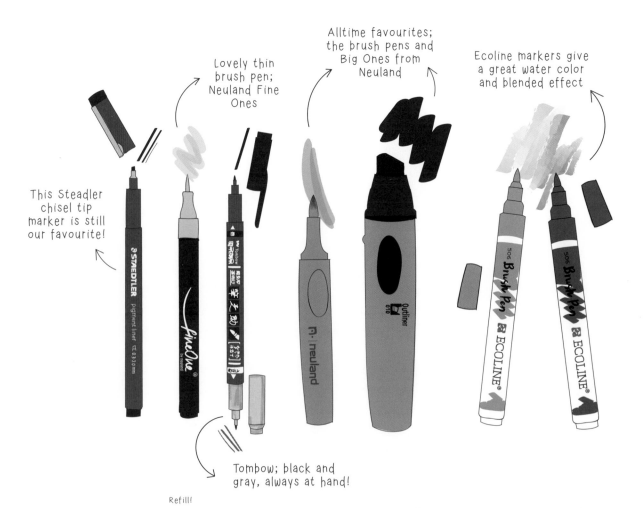

Lovely thin brush pen; Neuland Fine Ones

Alltime favourites; the brush pens and Big Ones from Neuland

Ecoline markers give a great water color and blended effect

This Steadler chisel tip marker is still our favourite!

Tombow; black and gray, always at hand!

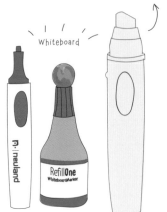

Refill!

Whiteboard

Tip: You can buy empty Neuland Big Ones and fill them with whiteboard ink. This looks amazing on your whiteboard.

Sophie

Name on tape

Tip: Writing in white marker on matte brown paper tape makes a great name tag.

Welcome!

2 great brands which are amazing on brown paper

2. THE NEXT LEVEL BASICS

This might just be the most important chapter of the whole book if you want to take your drawing and visual storytelling to the next level.

You've decided to tell a story and you're going to do it...visually! You've thought about the goal of your drawing and selected the information you want to include. You might have even made a sketch or visualized (parts of) the drawing.

The basic skills and guidelines in this chapter are the foundation of every drawing you will ever make. You'll learn how to:

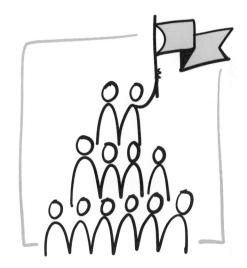

2.1 PREPARE YOUR VISUAL

You have decided to make a visual, because it will help you with problem X or Y. That's great! To really make an impact with your drawing, preparation is key.

This section will guide you through the steps. You'll get a clear idea of your goal, how you want to use your visual and in what setting. We will show you how to map your content.

After this, you are ready to get down to the creative work!

AFTER THIS SECTION, YOU WILL:
* Realize the importance of good preparation
* Know which steps to take for a flying start

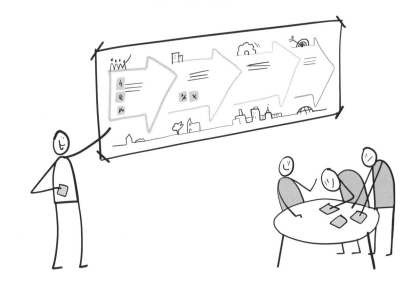

FIRST THINGS FIRST

You are so enthusiastic about the idea that you are going to make a visual story/drawing, you can't wait to start! Hold your horses for a second, and start by answering a couple of questions first. It will make you aware of your goal and the setting and helps you tune in to your audience.

A few questions you could (or should) always answer before you begin making a visual:

First, ask yourself why you are making a visual. What do you want to achieve with it?

1 WHAT IS THE GOAL?

☐ inform ☐ convince
☐ activate ☐
☐ inspire ☐

Always important to realize who your visual is for.

2 WHO IS YOUR AUDIENCE / TARGET GROUP ?

The core message is vital! Always make sure you know what it is before you start.

3 WHAT IS THE CORE MESSAGE ?
Try to write it down in a single sentence.

If you're not there to walk people through your drawing, it's even more important to create a self-explanatory image with clear visual cues to support your story.

4 WILL YOU BE PRESENT ?

☐ No, the drawing will be printed or distributed online.

☐ Yes, I will give a presentation, explanation, workshop or interactive session.

What if you have made a super big drawing and there is no space on the wall to display it? Or nobody can see it because there is a stage and your drawing is too small for the audience?

5 WHAT IS THE SETTING ?

▷ What is the setting and how is the room set up?

▷ How many attendees ?

▷ Is there a whiteboard, flipover, projector or a good spot on the wall? consider the wall's dimensions and the size of your drawing !

21

SORT OUT THE CONTENT

The core message may not be the only thing you want people to know. There could be lots of other content you want to share.

To map these elements, the first step is to have a stack of blank cards or post-its and write (or draw!) all the pieces of information on different cards. Try to think of all possible pieces of content you might want to use in your visual (a title, date, the why/how/what, stakeholders, a call-to-action, etc.).

Once you've written everything down on separate pieces of paper, lay everything in front of you to create an overview. Now the selection of elements begins. Be critical: Is there enough but not too much information to communicate your ideas?

Once all the elements are determined, cluster or categorize them by identifying themes. Optionally, try to establish order by arranging them as you see fit/logical. These tips could help:

- Lay your cards on a table or on the floor, so that you can see them all. Give yourself time to just look at the cards, perhaps rearrange them a couple of times and wait patiently until you see logic, patterns or something else that seems important for your visual story.
- You can prioritize your items. Use the MOSCOW method for example (as mentioned in the book Visual Thinking, p.90), but instead of 'must have', 'should have', etc., think: 'must tell', 'should tell', etc..

- Draw three big concentric circles. Tune in with your audience or goal and plot the cards according to relevance: the less relevant, the further away from the centre.
- If your story has some sort of chronological order because it follows a clear timeline or there is a cause-effect relation or some other clear A, B, C, ... Z progression, this could provide a straightforward and effective way of arranging your post-its.
- Since you are probably more experienced in talking and writing, try telling the story (out loud or in your head) and see what pieces of information you would talk about, in which order. That's the order in which you'd like the viewer to see them in your visual as well, thus your visual order.

We usually refer to this as card mapping. Stack cards together that are (inter)dependent.

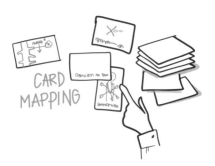

CARD MAPPING

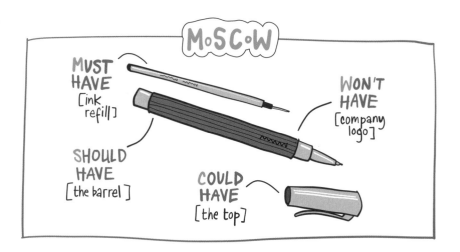

MOSCOW

MUST HAVE [ink refill]

SHOULD HAVE [the barrel]

COULD HAVE [the top]

WON'T HAVE [company logo]

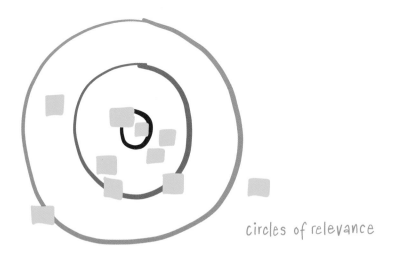

circles of relevance

As you can see in this visual, it is important to spend some time making clusters or categories of elements and ordering them, because the next step we take is to choose the most suitable plan and metaphor for your visual.

Stressing the important (stuff)

When you talk about something, especially if it's for an audience, sometimes you emphasize things by using body language, raising your voice and articulating r-e-a-l-l-y c-l-e-a-r-l-y. When things are not so important or are only small details in the bigger picture you lower your volume or might even mumble a bit. This is also an indication of order or hierarchy.

However, this is often on a smaller scale, for example within a paragraph where you have a key message and an explanation or proof of this message. Thus, within a cluster or theme there is the main message and the information that supports that message but is arranged "below" the main message.

Now you have established a hierarchy within your cards. Hierarchy is an arrangement of items, where the items are seen as "above", "below" or "at the same level as" other items. By adding a hierarchy you help your reader to determine where to start reading and you make text or visuals "scannable". Keep this in mind, as we will come back to this in section 2.5 'Visual hierarchy'.

23

CHOOSE UNDERLYING PLAN

Once you have an overview of your content and you've established clusters, let's see if a certain underlying plan emerges.

List/poster
From top to bottom. For lists such as agendas, programs and time-tables.

Steps/sum
From the bottom upwards. For roadmaps to the horizon or climbing (e.g. up a ladder).

Timeline
Left to right, A to Z, timelines, from one situation to another (change).

Road
A road or journey to the horizon, to the top of a mountain, steps to take.

Mandala
For brainstorms or when you have one (central) subject with details/features placed around it.

Matrix
A structured way to offer information, for example for dos and don'ts or a SWOT analysis.

Focus
For when there is one important visual you want to stand out.

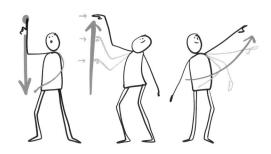

When telling the story, what movements do your arms make? It could tell a lot about the underlaying plan.

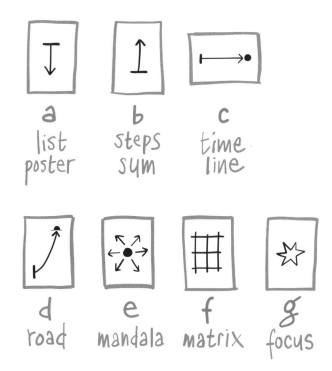

a — list poster

b — steps sum

c — time line

d — road

e — mandala

f — matrix

g — focus

You've done what you could to prepare your visual. Now let's take it to the next level! In section 2.3 we will come back to this and talk about composition, but before we do that, let's dive into the power of the right metaphor.

2.2 METAPHORS

AFTER THIS SECTION, YOU WILL:
- Believe in the power of the metaphor
- Know how to come up with your own metaphor
- Be familiar with a lot of basic metaphors

According to the dictionary a metaphor is "a word or phrase that means one thing and is used to describe something else to emphasize their similar qualities."

Metaphors grab people's attention, they connect the audience with our story, and they simplify complex, abstract ideas. We use metaphors all the time. When discussing sales and profit, the presenter talks about "seeds" and "growth." Someone will ask a question about "planning a route" and then someone else starts talking about "getting up to speed."

When it's really hard to stand back from what's happening and take stock, we need a "helicopter view."

THE POWER OF THE METAPHOR

As you seek to effectively paint a vivid picture in your audience's mind, the right metaphor will spark instant understanding and insight. By appealing to the part of the brain that processes visuals, you help them make the connection between what they already understand through experience and what they have yet to discover. Metaphors go beyond comprehension and demonstration, they could actually change the way we think of a concept at a subconscious level.

The following example, a 2011 study about urban crime by Thibodeau and Boroditsky, demonstrates how metaphors are key to shaping beliefs and points of view. In this study, crime was described to half of the participants as a beast preying on residents (an animal metaphor).

For the other half, crime was portrayed as a disease. Those who read the animal metaphor suggested control strategies, while those who saw crime as a disease proposed treatments. Simply changing the metaphor shaped people's reactions.

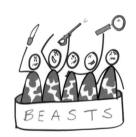

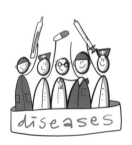

25

HOW TO FIND YOUR METAPHOR

When it comes to designing metaphors, there is an endless number of things you can use to make a comparison. So how do you make sure your metaphor is the best one? Easy: Just follow these next 6 steps to glory!

1. Understand

Understanding your subject is key to finding the right metaphor. "If you can't explain it simply, you don't understand it well enough," Einstein once said. To test for simplicity, imagine you have to explain your story to a 6-year-old.

2. (Re)Define

Think about how you want to use the metaphor. For instance, is your aim to clarify the subject matter or inspire action?

3. Ideate

Grab a pen and a lot of paper and start (visual) brainstorming. Write down key words, characteristics, visuals and ideas that pop into your head and explore visual associations. Studies have shown that writing by hand activates a different part of the brain and may even improve how you compose and express ideas.

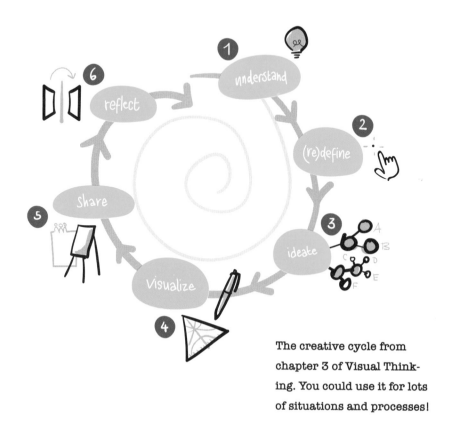

The creative cycle from chapter 3 of Visual Thinking. You could use it for lots of situations and processes!

To dig deeper, try these methods:

- Write down the obvious options right away just to get them out of your brain. After pushing past those, you will start to come up with more creative ideas. If we're trying to illustrate a partnership, we might begin with a cliché like a handshake. But maybe you want to express something more about that partnership. What elements are essential to your story?

- Reverse Thinking: This simple exercise might not lead directly to a metaphor, but it will jump-start your creativity. Think about the opposite situation. How would this look visually and what metaphor would you use?

- Random Input: Pick a random stimulus and try to see how you can fit it into your situation. Select a random word or image from a dictionary/webpage/book/magazine/newspaper/TV and think about how

it could apply. Or a random object from your room/house/workplace/neighborhood/etc.

• Get help: Take advantage of the full experience and creativity of all team and/or family members. Don't feed them the entire story just yet. Let them inspire you to visualize certain key associations, elements or 'feelings,' or try a 'random input' exercise to get them going. Once you have got their creative juices flowing, you can ask them the 'real question.'

Now it's time to flesh out the icons and metaphors. Does the situation resemble a ship in stormy weather or a growth process, for instance? Share and combine if necessary. Milk the metaphor but beware of clutter!

4. Visualize
Visualize your chosen metaphor(s) and see if all your story's elements fit into the metaphor. Often the metaphor will inspire

you as well. Keep an open mind and make connections. For example: If you are using a sailing metaphor, draw the surroundings as well. You can consider all kinds of features - the ocean, the weather, islands, lighthouses etc. You can then see if you can weave these elements into your visual storytelling.

5. Share
Pitch it to outsiders. Provide them with context and ask for honest constructive feedback. Questions that could help with getting feedback are:

• Does the metaphor provide more insight into the subject?
• Do you understand every detail of the metaphor and how it relates to the bigger story/bigger picture?
• What do you think about the choice of metaphor? Does it steer or change perception or opinion about the subject?

6. Reflect
Now reflect on what you have produced. What belongs and what doesn't? A good metaphor resonates immediately. Here you decide if you need to keep refining it or that it's good to go!

Some metaphors will be known very well by your audience. That can be a good thing, or it can become a cliché. Metaphors that are not well known by the audience can be very inspiring, but if you want your audience to actively point out similarities between reality and the metaphor, they might not be able to do so because of their lack of knowledge/lack of feeling with the metaphor.

In the next subsection we have laid out some metaphors that we encounter frequently. Use it as a source of inspiration!

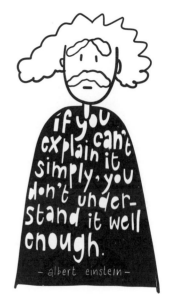

Tip: simplify! Pretend you have to explain your information to a six-year-old and pay attention to any visual clues and metaphors you use when doing so.

METAPHORS FOR INSPIRATION

Processes = journeys
A journey is planned in advance, with a defined starting point, route and destination.

Almost any sequence of events can be considered a journey.

Phrases that allude to this metaphor include; 'the way ahead', 'mapping out a route', 'on the horizon', 'wrong turning', 'milestones'.

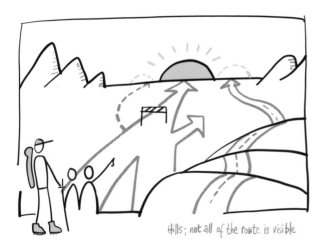

Hills; not all of the route is visible

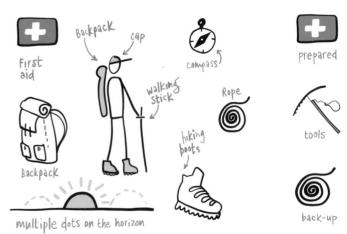

first aid

Backpack

cap

Backpack

walking stick

multiple dots on the horizon

compass

Rope

hiking boots

prepared

tools

back-up

To plan a route
Often used in strategic planning, drawing out a route on the map is an effective path towards a goal.

"We need to plan the best route to finish our task before the deadline."

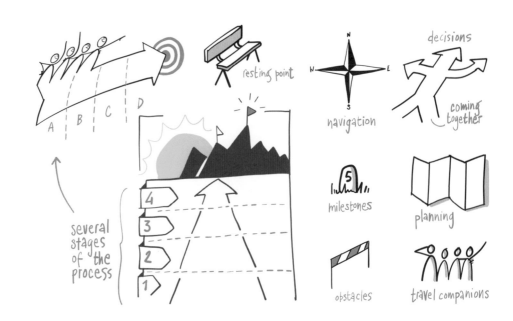

A B C D

several stages of the process

resting point

navigation

decisions

coming together

milestones

planning

obstacles

travel companions

29

Route metaphors are reflected in phrases such as 'define a clear goal', navigation, the preparation, the journey, landscape, time, distance, milestones, steps, stops, dangers, travel companions.

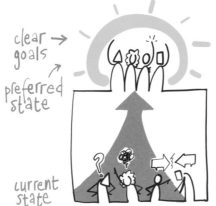

clear goals →

preferred state

current state

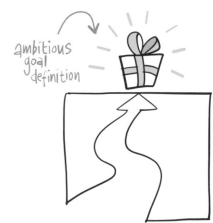

ambitious goal definition

Growth metaphors

"Hiring the right people sowed the seeds for the company's tremendous success."

Agricultural metaphors are reflected in phrases such as sowing a seed, plowing, current crop (of recruits), cutting out dead wood, bearing fruit, cross-fertilization, uprooting (staff), spadework.

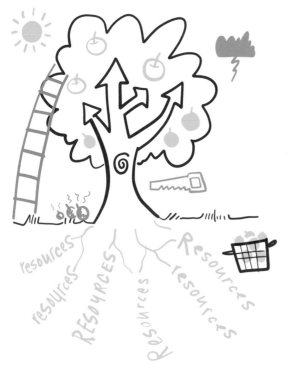

resources

 providing to grow

threats we cannot control but can anticipate

threats we can control

 high hanging fruit

 low hanging fruit

 rotting fruit

 our core (purpose)

 what do we need to reach our goals?

Each color representing a different aspect of the project we want to grow

tools to maintain growth

seasonal maintenance

getting rid of weeds

Strategy = chess

We use chess to symbolize strategy. Chess pieces have different values. A pawn for instance is less powerful generally speaking. Your queen is your most powerful element, and your king symbolizes your most valuable asset.

Accommodating or planning, hierarchy, control, resource allocation, gradual, development, competition an 'opening gambit', 'good (or bad) move', 'endgame'.

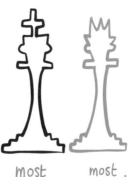

most important asset

most powerful asset

Competition

strategy

disposable assets

eliminated threat

Products = tools

A tool is handy, practical and perfectly suited to a particular job. The 'tool' metaphor conveys utility without flexibility. A hammer is perfect for knocking in nails, but pretty useless for measuring.

TOOLBOX

multitool

app

Business = war

The idea of business as war is reflected in a huge number of phrases.

Campaign, 'gaining ground' (e.g. on a competitor), 'reinforcing' (e.g. a firm's public image), 'joining forces', 'regrouping', 'rallying the troops',

'good ideas coming from those, 'in the trenches', 'productive 'alliances'.

enemy

campaign

#3 #1 #2

different ways to make an impact

impact descriptions

Organizations are like machines

"This organization runs like a well-oiled machine" It takes a well-organized process and a wide array of components to make it run smoothly. Optimizing a machine to get the most out of your resources.

Gears, process, oil.

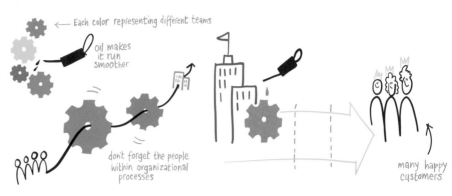

Each color representing different teams

oil makes it run smoother

don't forget the people within organizational processes

many happy customers

Career Path

A career path is the way a person progresses in their career.

"She followed an unusual career path. She started out in sales and now she is a lawyer." Paths, fork, overtaking, thinking over.

Career ladder

When you climb the career ladder, you get a promotion that moves you to a higher level in the organization.

'Robert climbed quickly up the career ladder.'

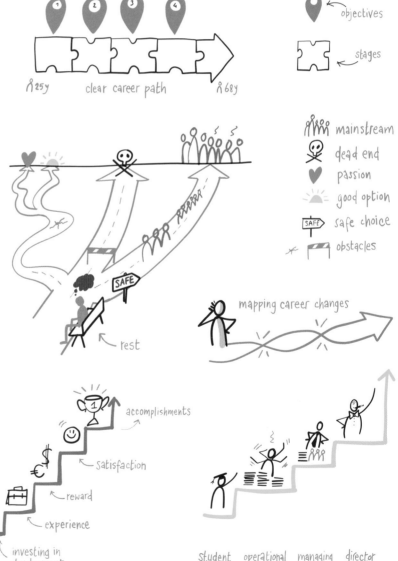

1 2 3 4

♟25y clear career path ♟68y

objectives

stages

ᔕᔕᔕ mainstream
☠ dead end
♥ passion
☀ good option
SAFE safe choice
obstacles

SAFE

rest

mapping career changes

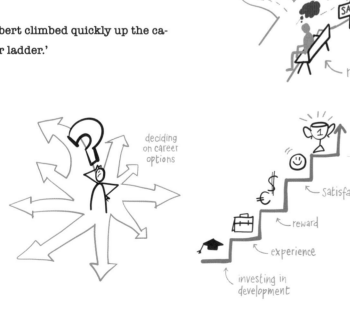

deciding on career options

accomplishments

satisfaction

reward

experience

investing in development

student operational work managing a team director

Progress = elevation

'Up' is usually associated with 'more' and 'better'. 'Exploring new insights".

'We are taking it to the next level' and 'onwards and upwards'.

what is working against us?

what is working for us?

we have control of direction

EXPLORE

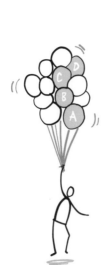

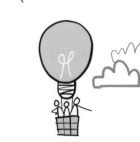
every balloon represents something that lifts you up!

exploring new ideas or frontiers

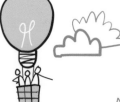

Heat lifts us up

Sandbags weigh us down

Anchor keeps us grounded

Animals = behavior

Animal imagery is very often mixed into other metaphors. Pay attention and you'll feel like you're in a farm or a zoo!

Headless chicken, chickening out, monkey business, black sheep, dark horse, red herring, elephant in the room, bull in a china shop, rat race

flexible, intuitive, curious

innovative evolutionary

big, clumsy, great memory

organized chaos

slow, consistent

fast, flexible

Wise owl

sheep, follow the leader

swimming against the current, courage, out of the box, autonomous

tiny, cheeky

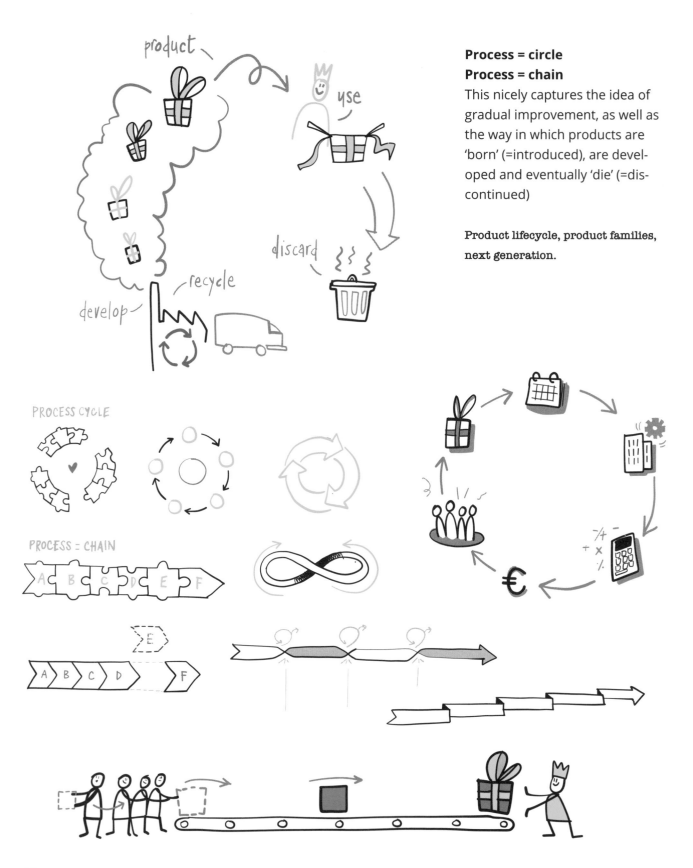

Process = circle
Process = chain
This nicely captures the idea of gradual improvement, as well as the way in which products are 'born' (=introduced), are developed and eventually 'die' (=discontinued)

Product lifecycle, product families, next generation.

product

use

discard

recycle

develop

PROCESS CYCLE

PROCESS = CHAIN

A B C D E F

E

A B C D F

Companies = ships

In this vivid metaphor a sense of unity is reinforced, while arguably over-emphasising potential dangers and the togetherness of the firm.

The CEO is the captain, the staff are the crew and the vessel needs to navigate the hazards of the business environment.

New recruits who 'come on board' are 'shown the ropes'. The leader might 'run a tight ship' as they 'plot a course' to success, navigating some 'stormy waters' along the way.

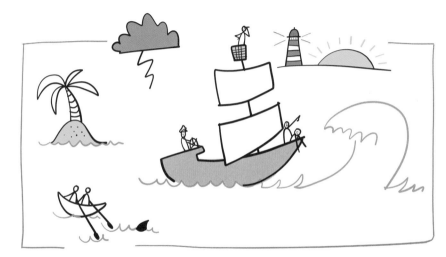

last resort

the man at the top, opportunity / threat, spotter

ultimate goal, a new horizon

bad weather

threats from below

safe harbor or route marker

manually powered team work

threats you can't avoid

Work = sport

This is about performance. Achieving potential and perhaps victory. The concept of 'high' or 'peak' performance is often reinforced with images of athletics, football, motor racing and so on.

'Get up to speed', 'left behind', 'level playing field' , 'final lap', 'shifting the goalposts', 'finish line'.

left behind (or fallen down)

getting up

running

get up to speed

Boxing

tug of war

2.3 LAYOUT AND COHERENCY

The most beautiful visuals can become hard to look at if the overall composition is flawed. All separate elements need to combine to form a unified whole. We speak of a good composition when all elements: visuals, icons, titles and text, come together to form one cohesive design.

It should not only look good, but it should also work with the story you want to tell.

AFTER THIS SECTION, YOU WILL:
• Know how to create coherency
• Be aware of different layouts
• Know what to do when a composition doesn't feel right

Most compositions have a strong focal point. This focal point is part of your visual hierarchy, a very important part of your visual. More on this in section 2.4 'Visual hierarchy'.

COMPOSITION

If you strip down your visual, the first layer will be the underlying plan, as discussed before in 2.1 Prepare your Visual.

If you work with a metaphor, your layout is often inspired by or based on this same metaphor.

Let's take the metaphor of time as an example. For some reason you want to draw something and the visual metaphor of a clock or stopwatch matches perfectly with the story you want to tell.

The layout is the clock with, let's say, the title in the middle and all the steps in the process around the hands of the clock, as seen on the right. The clock metaphor makes it inevitable that the underlying plan is a mandala or star.

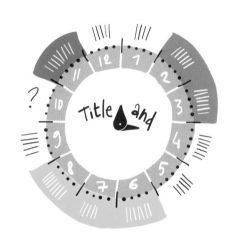

Layouts

On the right you will find several layouts you could use as inspiration or a base for your drawing. These layouts are a little more detailed than the underlying plan, but you can still see the plan hidden in the layouts.

Tip: Dividing you drawing into thirds (or in two or four or .. columns) never hurts.

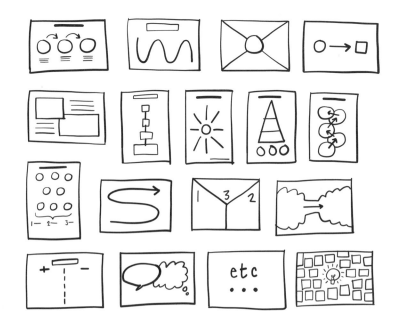

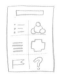

Composition and metaphor

Once you have chosen a metaphor, there are still a lot of compositions and drawings possible. The key is to find the most suitable one; the one that gives all your elements the spotlight they need or deserve. It could help to determine beforehand which plans are a logical fit with the content of the visual or which are not.

To find the right one, take a blank piece of paper (or a stack of papers) and just start sketching. Give your creativity free rein (to use an animal metaphor!). On the right you'll see a sketching exercise focused on the metaphor 'space'.

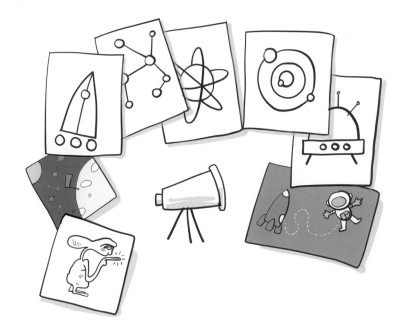

Here you see a lot of mandala and focus-like layouts. but if that doesn't match your content-elements, there are plenty more options!

COHERENCY

You are visually communicating. In order to keep your audience's attention focused you have to create a harmonious picture. Balance visual elements and organize them neatly so your audience doesn't have to do that for you!

This can happen for example when you have a left-to-right symmetrical imbalance by leaving a lot of white space on the right and none on the left.
A good technique to avoid imbalance is to think of each element as having a 'weight.' Smaller objects might 'weigh' less than larger objects, and heavily crowded elements might 'weigh' more than relatively empty elements (the same goes for dark elements versus relatively light elements, etc.).

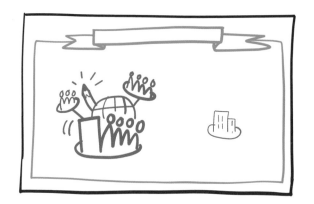

A great way to create coherency is to repeat visual characteristics of the design throughout your piece. You can repeat color, shape, texture, spatial relationships, line thicknesses, sizes, etc. This helps develop an order and strengthens the unity.

Tip: Give your drawing the attention it deserves. Take time to think about unity and ways to create a coherent visual.

Coherency and meaning: repeat visual characteristics (color in this case) to tell people certain elements are linked or belong to the same category.

Repetition of shapes, color and line thickness to create a harmonious picture, versus little repetition or balance.

Although the elements on the left differ from the ones on the right, the visual is still balanced because the 'weight' of the two sides is about the same.

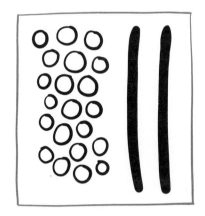

Drawing a frame is always a good way of creating instant unity (see section 2.5 for more).

A good color scheme is a simple yet effective way to create coherency, too. Color schemes based on a single color tint are one of the easiest to use. This doesn't mean you should only use a single shade in multiple places in your design (although you could!). Instead, choose one main color, and pick any number of variations of that color.

As said before, coherency can also be accomplished by the repetition of line thickness or shapes. If you draw with a very loose, 'sketchy' style, it would be strange if there suddenly was a very tight visual element in your drawing.

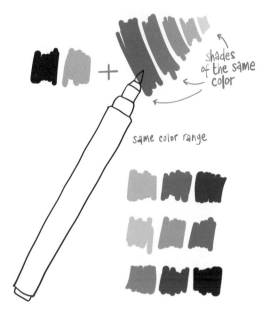

shades of the same color

same color range

Tip: You are probably drawing in a business setting. So make the most of your environment. Use the company's corporate color scheme in your drawing (it should be a well-balanced palette already).

2.4 VISUAL HIERARCHY

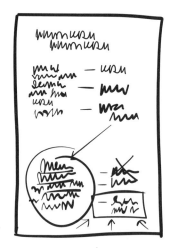

Your drawing now

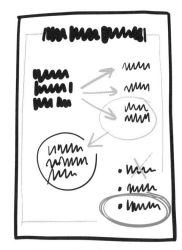

Your drawing's potential

AFTER THIS SECTION, YOU WILL:
- Understand the value of visual hierarchy
- Have learned different methods used to distinguish elements
- Have seen examples of visual hierarchy in drawings
- Know how to check whether a drawing has a form of visual hierarchy

We'd like to start the section with an example of a type of drawing we unfortunately see all too often. The one on the left: one color, one thickness, no visual clues as to where you should begin looking and where to continue. In short, it lacks a visual hierarchy.

You want people to look at your drawing and actually "read" it. The drawing above gets in the way of that process. You're adding to cognitive overload since your viewer's brain will have to put a lot of effort into simply deciding where to start "reading" and where to continue (what's important and what's not).

As viewers, we see the whole before we break it down into individual parts. This is important to realize, because once we have seen the whole and our focus shifts to see the individual parts, they (the individual parts) start to compete for our attention. This is where you want to guide your viewer through the visual.

In the section 'Prepare your Visual' you have read about tools to help distinguish main and side issues and to establish an order in your visual elements. Now let's look at how to visualize these elements to maintain this order.

When you have a good visual hierarchy your viewers can also SCAN and SKIM your drawing

FOCAL POINT

Your key message, idea or most important visual needs a strong focal point. Be sure to choose a focal point that helps tell your story in the strongest, most effective way. Here are some methods and examples of how to create a focal point in your image:

Thick over thin lines
When you look at this image, the element that jumps out at you is the one drawn with thick lines.

Black over gray
The black element is more eye-catching than the gray element, thus it is "above" the gray element.

Leading lines
Literally pointing out where to look with either arrows or lines is an effective way to create a focal point.

Color
By adding a bright color to (a part of) your drawing you create a natural focal point. Color is a powerful tool. But be careful! Its strength can become a weakness if you use too many different or clashing colors. Less really is more.

Positive use of negative space
Whitespace, often referred to as negative space, can be used to establish a hierarchy too. In this example, your eye is drawn to the part of the drawing that is the most dense and has the least whitespace.

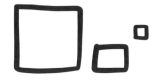

Size
When one element is way bigger than another element it is placed on a higher level in the overall hierarchy.

Contrast
If your drawing has a white background you can create a contrasting (colored or even black) plane to draw people's attention to the information it contains.

JUST LIKE TALKING OR WRITING

If we compare drawing to talking (again), think of a storyteller who, instead of talking louder, starts whispering to create tension and demand your attention. The visual equivalent of this could be using a lot of whitespace. If you're talking and you're using a lot of words that indicate contradictions (i.e. but, however, though, on the other hand, etc.) using contrast could be a logical visual way of expressing the contradictions.

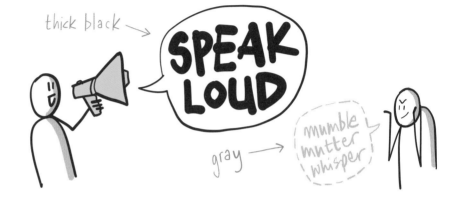

Even when you only use text, a visual hierarchy is important. Think of the front page of your newspaper. The big, bold headline grabs your attention; a photo and caption give a visual over-view of the main story and bold subheadings break up the main text. The paper's subeditors use 'size' (fontsize) and 'thick over thin lines' (bold or regular letters) to engage readers.

HIERARCHY HOW-TO

A visual hierarchy embodies more than just a strong focal point. It has more levels of attention. However, when you create a hierarchy in your drawing you can use the same methods as mentioned above, you just have to extend and exploit them.

An example of how to deal with hierarchy
We mostly use 'black/gray' and 'thick/thin lines' to create hierarchy (although you can of course use other methods, such as 'size' or 'whitespace'). There are a few rules of thumb that, to a certain extent, we always follow to add visual hierarchy to our drawing:

1. Your title is always important and "above" anything else (in terms of hierarchy). It has the same value of attention as a thick black line.
2. Change from thick to an increasingly thinner line to visualize something that is slightly less important (the subtitle, for instance).
3. Use thin black lines for regular content, such as shapes and faces. At this level, there are three sublevels: thin black lines with a gray shadow, thin black lines without a shadow, and thin black dotted lines without shadow.
4. Arrows and dividers are (almost) always gray. Often they are inferior to and supportive of the content and thus should not be black. This way they won't distract by attracting too much attention or compete for attention with informative elements. They can be used as guidance, to direct readers or to divide different areas in your drawing.
5. If you would explain something in a whisper or if you're not sure about something, use gray (dotted) lines.
6. Color can be added literally to highlight. Use this for the conclusion or summary, or use it to focus on something funny or exciting. Don't overdo it (don't add color to each and every element), then it loses its power.

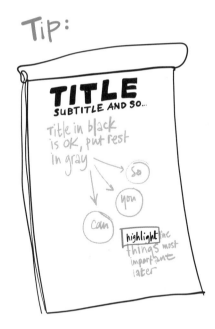

Arrows indicate the reading direction. So never make them black, always gray!

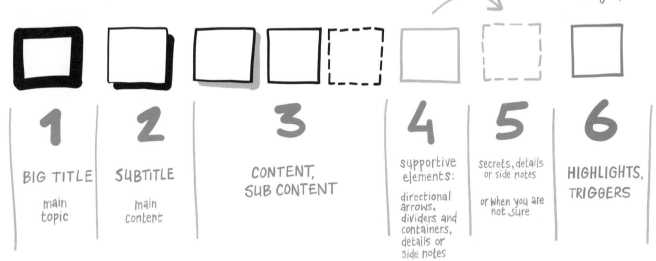

TIP: We would advise having no more than six 'levels' on which you plot all your elements

TIP: Not every element has a place 'below' or 'above' other elements. You can have a variety of elements on the same level as each other.

A visual example of hierarchy

Let's have a look at the drawing below. The first thing that catches your eye is the (big) banner that says 'Willemien Brand'. Thick black lines are used and a color highlights the element even more. The self-portrait is the second element that asks for attention. It is one level below the banner but still very prominent (that is also due to the central placement, more on this in chapter 2.5). The third level in this drawing consists of several elements: those located above and around the self-portrait. Last but not least you have a couple of elements inside the body. In contrast to all other elements these are drawn in gray, no thick lines are used and therefore they are on the lowest level of the visual hierarchy. They could either be the least important or the visualizer wanted them chronologically to come last.

Note that an element itself can also have different levels of hierarchy (on a smaller scale), as shown by the red numbers in the drawing below

Methods used: Black versus gray, Thick versus thin lines, Size, Color.

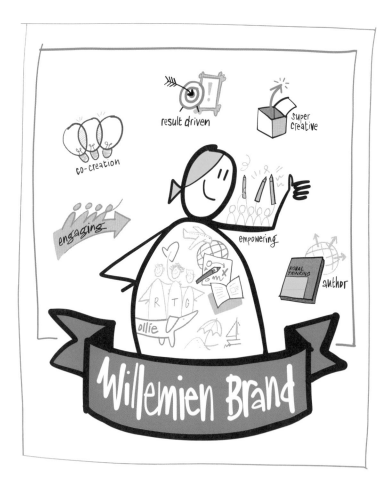

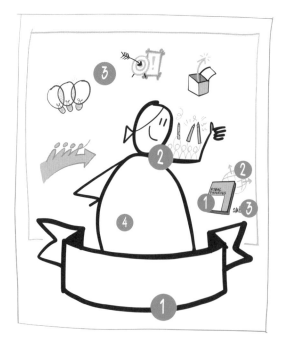

TIP
Start with gray and build the visual hierarchy afterwards.

HIERARCHY-CHECK

For a quick "hierarchy check" there are two things you can do.

1. Pretend you don't know your own drawing and try to scan it. Ask yourself: is the subject of the visual clear (i.e. is there a striking title or banner)? Is it clear what pieces of information you can find in the drawing (and where)? Is there a particular order in which you have to look at the visual chunks of information and is that order clear? Is the goal of the visual clear (i.e. is there an (obvious) call-to-action)?

 Tip: Invite somebody to look at it. Ask questions such as: What is the first thing that strikes your eye? And the second? What is the subject of the poster? What do you think the core message is? Why do you think this poster is made (with what reason)?

2. Squint until your vision is blurry. Now when you look at your drawing, you'll probably see something like a (gray) blurred mass where your drawing used to be. If all you can see is a relatively smooth gray mass it means there is little discrepancy between your pieces of information and therefore there probably isn't an obvious hierarchy. If you see an irregular gray drawing, with dark or black spots and white or lighter spots, that means there is a lot of distinction between your different elements and therefore there is probably a good hierarchy.

 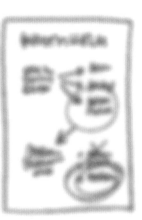 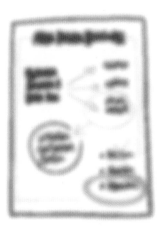

Remember: you want your drawing to be as (visually) accessible as possible.

2.5 FRAMES AND CONNECTORS

Here you'll find visuals to connect elements with each other, divide one area in your drawing from another, and visuals that contain elements or frame groups of elements.

AFTER THIS SECTION, YOU WILL:
- Have learned some building blocks to create a compelling visual story

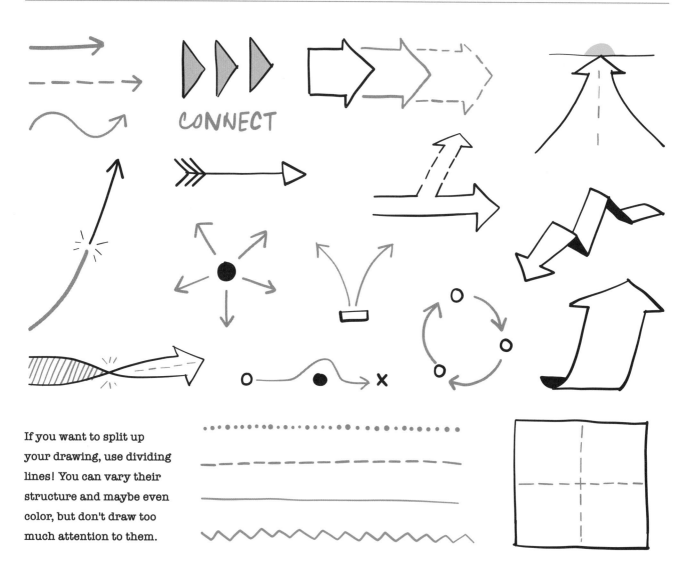

If you want to split up your drawing, use dividing lines! You can vary their structure and maybe even color, but don't draw too much attention to them.

Set an element apart by placing it in a container. Very common are the mile markers next to the road(map) that indicate where we are on the road chronologically.

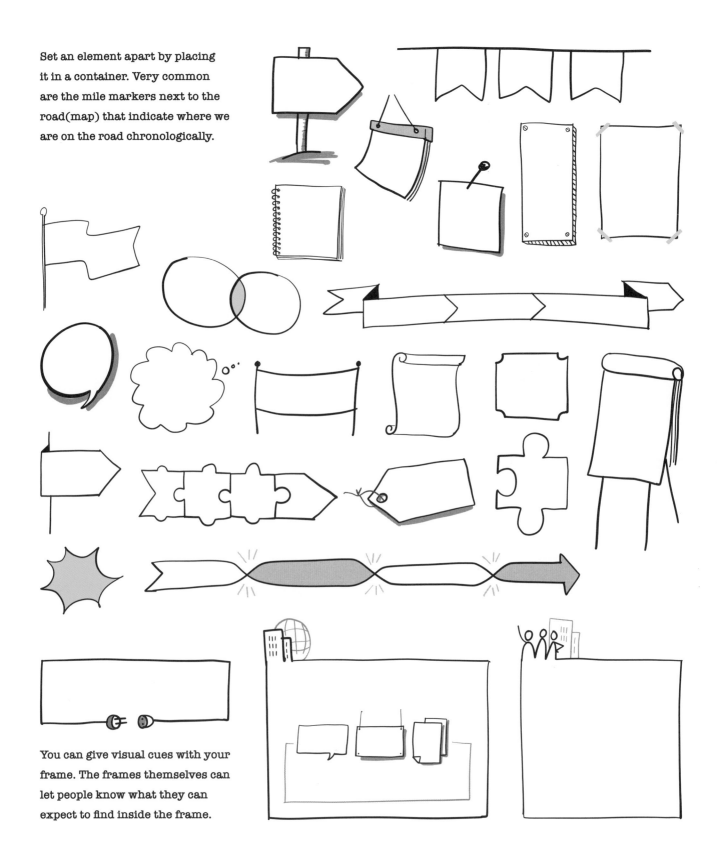

You can give visual cues with your frame. The frames themselves can let people know what they can expect to find inside the frame.

2.6 VISUAL ARTICULATION

It is great to see the growing number of people who dare to use drawing to express their (business) ideas! Unfortunately there are still too many drawings that look like the one on the left, where people draw as fast as they talk or think. With one color, no distinction between elements and messy forms.

It's a missed opportunity to make your visual approachable, appealing to the eye and to lure people into your visual as a way of spreading your message

AFTER THIS SECTION, YOU WILL:
- Understand the value of articulation
- Remember to draw with care: always draw half a second slower than you want to

your drawing now

your drawing's potential

ARTICULATE

When you talk, you aim to speak in full, comprehensive sentences. You don't (or at least you shouldn't) stop midway through a sentence or leave it incomplete. When you are giving a speech, you don't mumble; you articulate clearly to get your message across. You have to apply these same natural and obvious "rules" when communicating through drawing. Because when drawing, it seems that these rules are not always that obvious. Let's break them down:

Visual articulation:

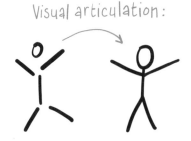

1. **Close your shapes** (the visual equivalent of finishing your sentences/words). Look at the two squares below. When your eyes look at the first square, they register four lines. Almost unconsciously your brain transforms it into a square; it has the tendency to complete unfinished objects and close shapes. The second square, however, is registered immediately as a square. Without any additional effort and with no room for misinterpretation.

2. **Connect combined elements** (hyphenate words). When two elements belong together, make sure they have a visual connection, as seen in the first drawing below.

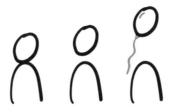

In the second one, the head and body are still connected. In the third drawing though, the head is too far away from the body for them to be visually connected

3. **Separate different elements** (punctuate your text). A simple example: when you draw a face, the mouth and eyes have to be detached from the outline of the head.

A banner and a frame, or a building and a globe: both examples where you can separate the elements even more, visually, by using different colors.

Don't: Do

facial expression
and other details
always with
a finer pencil

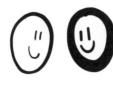

don't hit the outerline,
keep white space around
the facial expressions

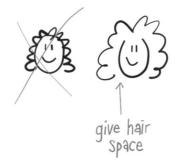

give hair
space

Tip: Look closely at the point where you started drawing your circle and continue looking at that point until your pen reaches that point again to close the circle. It's just like driving a car; look where you're going, don't look at your steering wheel!

Tip: You have more time than you think! Try to take half a second longer for your drawings than you would normally take, to ensure you close your forms, to draw confident, smooth lines and to write legibly. Keep these 'rules' in mind when reading (and doing) the next chapter.

2.7 HOW TO MAKE A VISUAL
A SUMMARY

Whatever poster we make, we always follow the same steps; from divergence to convergence. From your starting point, diverge; explore all your options. Next, converge; eliminate ideas that don't work and focus on those that make the most sense.

2.1 Prepare your visual
Prepare by nailing down the poster's goal and target audience. Note down all the content you need to communicate your story. (Diverging again!) Then be critical. Decide which elements to keep.

(Converging again!). Divide what you keep into categories – now you have the building blocks for your poster! A plan might already start to emerge from this process.

2.2 Metaphors
Come up with a suitable metaphor. This is a whole new process on its own, with (you guessed it!) diverging and converging stages. In reality, people often already talk in metaphors while discussing the subject at hand. It doesn't hurt to investigate other possibilities (read section 2.2 to learn how), but the first one you

thought of could well turn out to resonate most clearly with your group or audience. To check if you have the right metaphor, ask yourself a couple of questions:
- Is the metaphor clear and does it clarify the subject?
- Does the metaphor steer or change perception or opinion about the subject (and is that your aim)?

2.3 Layout and coherency
Time to use the metaphor and design a composition. Ask yourself which plans or layouts match your story and metaphor.

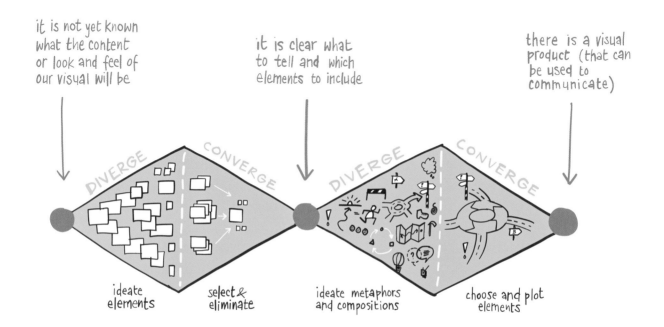

it is not yet known what the content or look and feel of our visual will be

it is clear what to tell and which elements to include

there is a visual product (that can be used to communicate)

DIVERGE · CONVERGE · DIVERGE · CONVERGE

ideate elements · select & eliminate · ideate metaphors and compositions · choose and plot elements

Sketch possible compositions. (Diverge). Step back and see which sketch works best with the elements you have to tell the story. (Converge) If you like, you can plot the elements on the composition sketch to see what should be where.

Now that you've chosen a design, it's important to check whether it is balanced and to create a coherent visual when drawing up (a cleaned-up version of) the poster. Remember that creating balance in a picture can be achieved by thinking of each element as having 'weight.' You can create coherency by repeating visual characteristics, such as shape or color.

Tip: Explaining whether you are diverging or converging can help people get in the right mindset and understand the task at hand.

2.4 Visual hierarchy

When drawing the 'final' design of the poster (or the next iteration), make sure your drawing has a clear visual hierarchy. Check section 2.4 for an overview of methods to create a strong focal point or a more elaborate visual hierarchy.

To check if your poster has enough visual hierarchy and has the right elements in the right order to clearly convey your message, invite someone over to look at it (or try to do it yourself, with 'fresh eyes'), and ask questions such as: What is the first thing that strikes you? And the second? What is the subject of the poster? What do you think the core message is? Why do you think we made this poster?

2.5 To frame or not to frame

We often draw a frame around the poster to bring it together and literally frame where people should look. A frame doesn't always work; make sure it is subtle and supports the drawing (so don't use a thick black line that will compete with the poster's important elements or create imbalance).

2.6 Visual articulation

This is important in all earlier stages of making a visual, but especially when finalizing the actual design: Draw with care! Close your shapes, visually connect elements that belong together, yet separate them enough so that they can still be identified as two (or more) different elements. Final tip: Be confident. Draw (or write) half a second slower than you would normally.

When drawing, use colored markers that match the branding of the organization or your team's colors.

You can ask a professional to take your drawing to the next level. However, a slightly messy visual created by you or your team might work better than a beautiful, clean poster or infographic created by a professional visualizer.

ARE YOU READY for the NEXT STEP?

3. LET'S GET VISUAL

In the previous chapter you learned how to build up your own visuals by using blocks, containers and visual hierarchy, and how you can use a metaphor to tell a visual story. Now it's time to work on our visual content!

We will take a look at some typography and drawing people and icons based on basic shapes. Just as in our first book, it's not about being a Picasso, it's about mastering an easy way of drawing and interacting with your audience in a visual way.

Less lines, more impact!

If you start combining basic shapes and icons you can create a whole range of interesting new visuals. We give you loads of examples but the internet is an inexhaustible source of inspiration and information.

By tracing or copying images you will learn to draw and combine even more.

Because people ask us for this all the time, we are giving you some great examples of visual icons that can be applied to business themes. A word can, of course, have a different meaning depending on its context or the people discussing it. If you ask a group to draw 'compliance', you will get a range of different drawings which are all great and all correct! You will see that there isn't one single way to successfully visualize a word or sentence.

Using just your own handwriting, enthusiasm and (visual) knowledge you can connect the dots of a complex issue to create a compelling visual that brings across your message in a way that is easy to understand and remember.

3.1 TYPOGRAPHY

This is, of course, a book about drawing. But that doesn't mean we are banning words. On the contrary! However, if you choose to use text, please make sure your writing complements your drawing and is easy to read. Your own handwriting is often not approachable and adds to cognitive load of your readers/viewers. So, what are your options? What typography should you use when?

AFTER THIS SECTION, YOU WILL:
- Know how to make tiptop titles
- Know simple ways to make awesome content

TITLES

For big titles, use a short text or a single word to summarize your subject. Make sure you use some simple capital letters or the outline font. For extra attention add for example a shadow and add a frame to bring together your content.

Capitals
Use lots of whitespace between the letters and make sure all letters have about the same height.

Outline
Very eye-catching. Especially with an extra effect, such as 3D, shadow or an extra outline around the whole word.

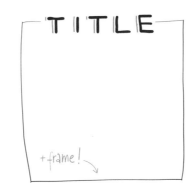

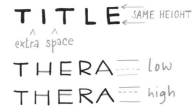

Tip: play with the height of horizontal connection lines and reinvent your own handwriting.

SUBTITLES

Subtitles or titles for themes or catagories are quite important too and should stand out from regular content, but should not compete too much with the main message or title.

black background + white paintmarker !

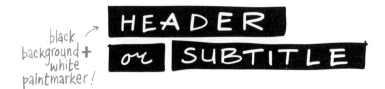

HEADER or SUBTITLE

abcdefghijklmnop
qrstuvwxyzx

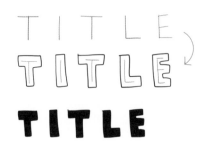

If you are new to the outline font, you can start by writing a word in your normal handwriting. Then trace an outline around the word to create a stencil of the letter.

CLOSED

CONTENT TYPE

We often use handwritten content in our drawings and the beauty of how we write our lower-case letters is that almost every letter can be made in two steps (hence our nickname for it: the 2-step font).

When you want to add a play-fulness to the letters, as we like to do, extend every vertical line upwards and/or downwards.

Make sure all the lines are connected. No open ends!

ʔ a – e
STEP 1 STEP 2 STEP 1 STEP 2

l b ∪ y
STEP 1 STEP 2 STEP 1 STEP 2

Tip: is your handwriting a terrible scrawl? This "2-step-font" will vastly improve it! The vertical lines (make sure you keep them all vertical) will give it a simple, relaxed rhythm.

You can experiment with the tops and bottoms of the vertical lines, but make sure your 'p' doesn't turn into a 'b' or your 'n' into an 'h'.

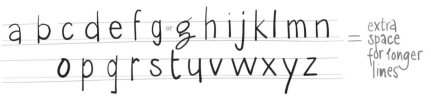

a b c d e f g or g h i j k l m n = extra space for longer lines
o p q r s t u v w x y z

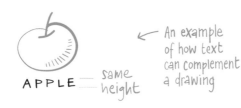 same height

 An example of how text can complement a drawing

apple ^ ^ ^ space

We can't emphasize enough how much we love whitespace. It is so much easier on the eye and it helps you write more slowly and therefore more neatly.

Instead of fast writing, try to 'draw' the letters. Take more time than you usually would. Try to put your text in a block, readability is key!

Tip: Writing ALL CAPS makes sure your writing is legible and more neat (and therefore approachable) than your own handwritten scribbles. Your visual will easily look more professional.

Different pencil, different outcome! Even the way you hold your pencil makes a difference. Try various shapes and colors and pick your favourite.

enough space

TRY USING ALL CAPITALS. BE CONSISTENT. MAKE LETTERS THE SAME HEIGHT AND MAKE SURE YOU LEAVE ENOUGH SPACE BETWEEN THEM

Typewriter font

If you want to create a vintage typewriter font, start by writing your text in your own handwriting or use the 2-step font. Once you are done, just add some extra lines to the ends of all letters and voila!

d → d T T ↘ just add lines

a b c d e f g h i j A B C D E F G H I J
k l m n o p q r s t K L M N O P Q R S T
u v w x y z u v w x y z

TOP TITLE HEADER, ← also great for a title!

Old school handwriting

If you are big fan of handlettering you will like this font! The old school handwriting is great for quotes or short lines of text. It also works well when combined with other fonts.

old school handwriting

o h tar ← make loops to join letters

BUSINESS *drawing* ← combine 2 fonts

56

3.2 DECONSTRUCTED DRAWINGS

To learn how to make more complex drawings, you first need to break them down. All drawings, however simple or complicated, are made up of basic shapes and forms. In our first book, Visual Thinking, we briefly discussed the form alphabet. That is a set of simple shapes which together can create basically any object you want to draw.

AFTER THIS SECTION, YOU WILL:
- Understand the form alphabet
- Be able to break down visuals
- Know how to build new images using basic shapes

Afraid of perspective drawing or 3D shapes?
No worries, you don't have to use them.

↳ *make things easy to draw*

IF YOU CAN WRITE, YOU CAN DRAW

The fact that letters are also shapes becomes clear if you have ever tried mirror writing. All of a sudden, you start seeing your letters as individual shapes. This is a great insight!

This theory is explained by Martin Haussmann in his book *'UZMO, thinking with your pen'*, where he demonstrates that if you can write the letters UZMO, you can draw a lightbulb. This can be a eureka moment for you!

effect lines in other color

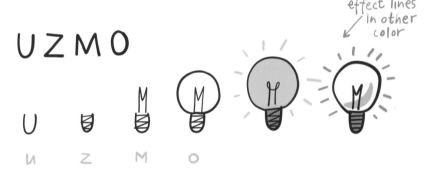

If you've mastered this, you can also try to create your own UZMO-like drawing. Using just the letters VOICIS, for example, you can make a speech balloon with a horizon inside. Of course you can use your letters upside down and mirrored as well.

Tip: try to come up with your own UZMO-like drawing. This is fun and easy to remember!

VOICIS

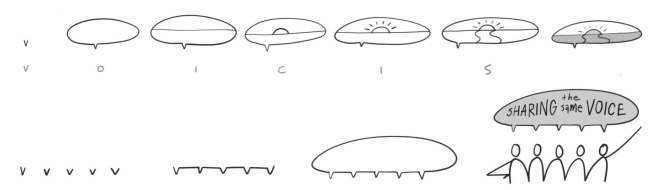

BREAKING DOWN THE SUBJECT

So we've seen that simply by knowing your alphabet and basic shapes you can draw almost anything you want; you just have to know where to start! In this subsection we will break down some visuals in order to help you see, understand and practice this theory. Because drawing is a form of communication -as shown in our communication triangle in chapter 1- you want to express your message clearly. And in order to communicate by drawing you don't really need stuff like 3D and perspective. Unless, of course, you are specifically talking about these subjects.

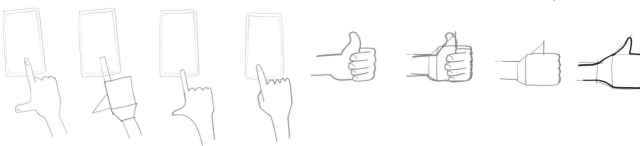

In chapter 2.4 we explained visual hierarchy and the fact that your audience will see your picture as a whole before they start seeing individual icons and elements. If we take another step back, the same happens when you see a drawing of something. For example, you immediately see an elephant, but not the different shapes and forms that combine to create it.

Drawing an elephant may seem complex, but don't freak out! Take a closer look and you will see that the body looks like a big oval. The head looks like a circle and the legs are rectangles. Always start by finding the biggest shape and start working from this point.

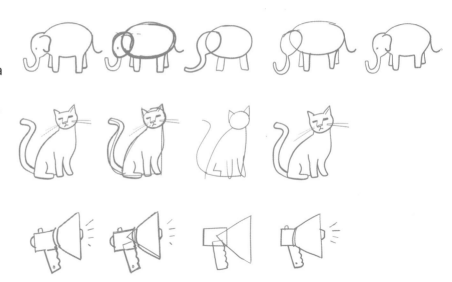

Tip: If you find your drawing a bit angular, try to round your corners for a softer look. You can start with a grey marker or pencil and trace with black or a color.

YOU CAN DO THE MATH

As soon as you start seeing objects as combinations of basic shapes -or letters if you like- drawing becomes a lot easier; you can even do some drawing mathematics! In chapter 3.4 you will build up a combined visual from a lot of loose icons, so let's break them down first, categorized by the basic shapes of the form alphabet.

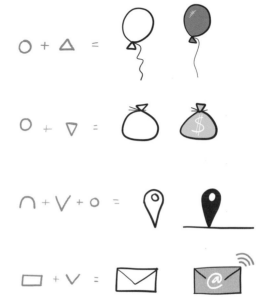

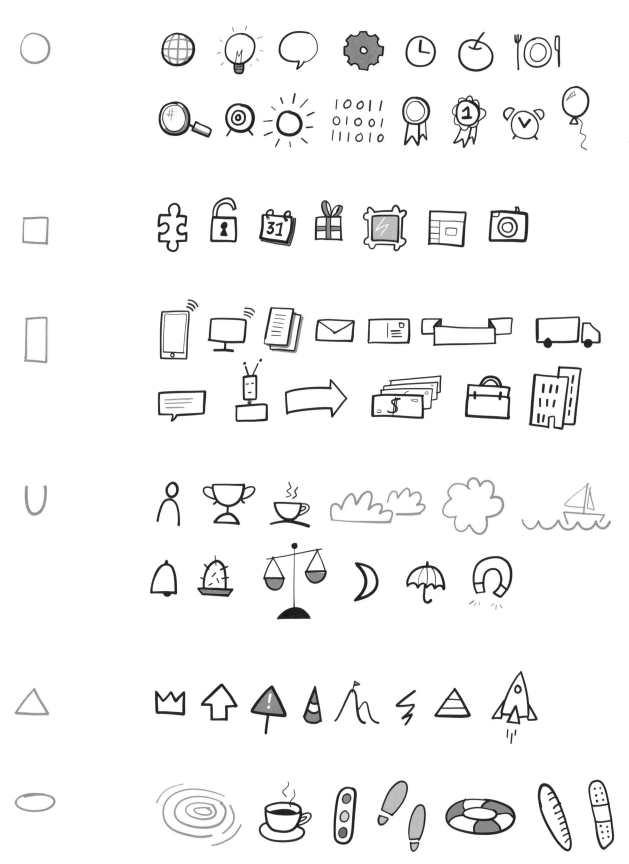

3.3 PEOPLE AND ACTIONS

AFTER THIS SECTION, YOU WILL:
- Know how to draw basic people, jobs and actions

You now know your basic shapes and have seen how easily you can combine icons into a combined visual. Let's take a step back and focus on some basic icons, people, facial expressions and postures first, followed by some great personas and icons you can use at work. We will give you loads of examples which you can copy or combine into your own visual.

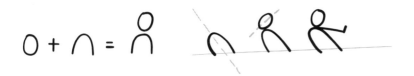

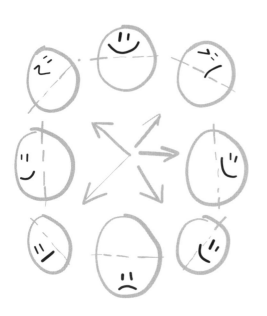

By paying extra attention to the view direction of the person you draw, the visual will stand out even more and tell a more convincing story. Use the view direction wheel as a reference.

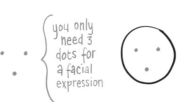

you only need 3 dots for a facial expression

use lines instead of dots for the eyes; it's faster and you have more control over the outcome

This 'view direction wheel' shows you how to direct a face's view and gives you an example of some facial expressions.

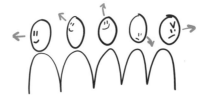

61

POSTURES

As well as view directions and facial expressions, you can make people stand and move in a lot of different ways. You can rotate the torso for extra movement -as seen in the balloon visual on the right page- but you can also add expression and movement lines to your drawing.

If you are not sure how to draw a posture, ask someone to model for you or strike a pose yourself. You can also just use your imagination.

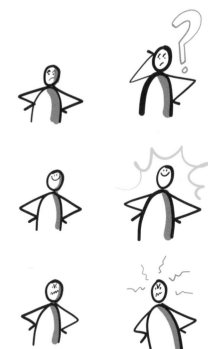

BASIC
FIGURE

BASIC FIGURE
WITH EXPRESSION
LINES

BASIC FIGURE
WITH FACIAL
EXPRESSION

BASIC FIGURE
WITH FACIAL
EXPRESSION
AND EXPRESSION
LINES

When in a hurry,
this is the
most effective
way

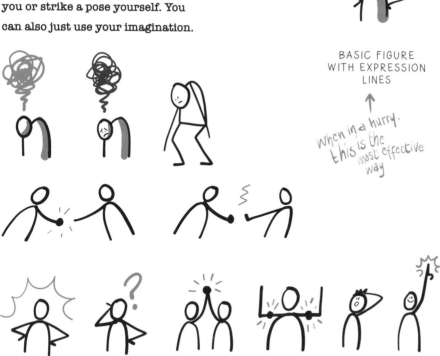

Tip: arms grow from your shoulders, don't let them sprout out of a torso.

arms ?

In chapter 2.4 we talked about visual hierarchy. This is something you also use in smaller drawings such as 'people going places'. You can draw movement lines and accents in a different color to the main subject. This makes the drawing easier to understand and more attractive for your audience.

Tip: try to keep in mind the directions arms and legs can bend. Don't let them break!

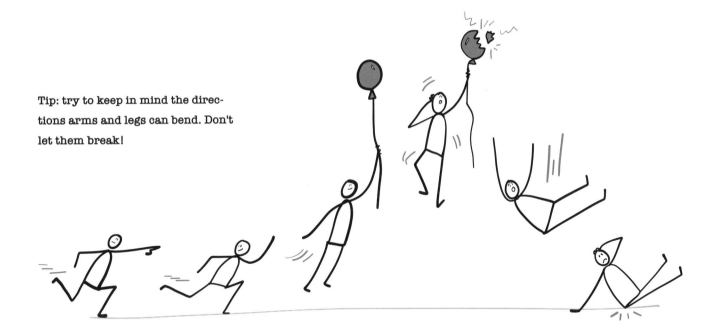

If you want to draw people in motion, always start with the body. Draw the torso in the direction the person is moving (see the running guy). Finish your drawing with the head, arms, legs and movement lines.

Of course, you can make variations to your figures. You can draw the legs and body in one or try a more rectangular body for example.

Drawing 'accomplishment' in different styles.

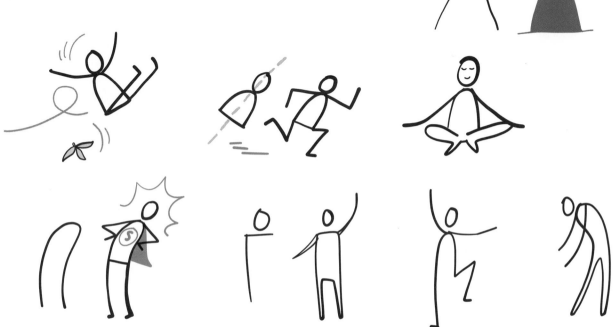

PERSONAS AND JOBS

In business environments, you may need to visualize a job or persona. This might seem complicated, but once you know how to draw basic figures, it is not so hard!

Think of some characteristics of the job or person you want to draw. Think over the top and stereotype, this process of simplification helps distil a complex idea into an icon.

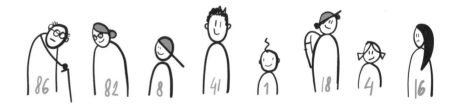

If you are drawing a family or a group of people, write their ages in the belly and you are done. For example, add some gray hair, glasses, write 82 in the belly and you've visualized your grandma.

Tip: If you don't know how to draw a job, take a look at websites like the nounproject.com or use google images to get inspiration. For example, search for 'lawyer icon' and see what comes up.

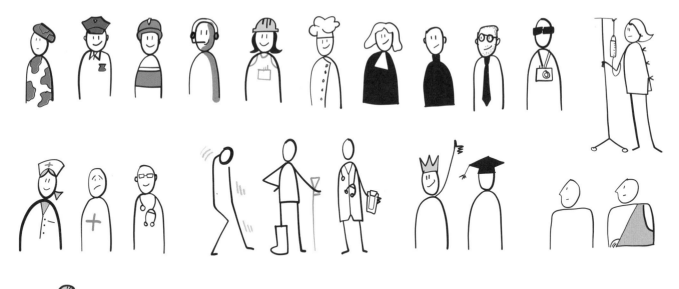

Did you spot Steve Jobs with his signature polo neck sweater?

INTERACTIONS AND THEIR STORY

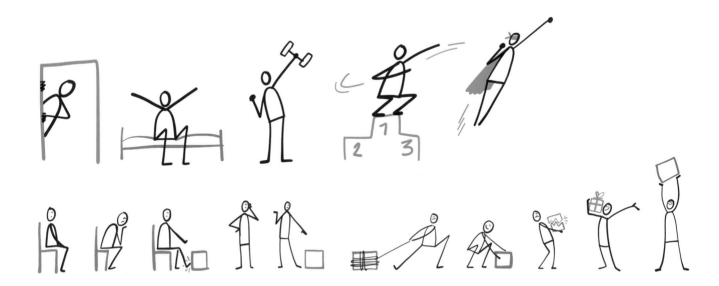

Once you've mastered different postures, people and activities, you can start visualizing your story.

See if you can come up with a story for the person looking around the corner. Is he waking someone up? Does this guy go to the gym or is he a secret superhero?

A drawing can develop and grow while you're drawing it. But it can also unfold while you are talking -and drawing at the same time- with your team, for example.

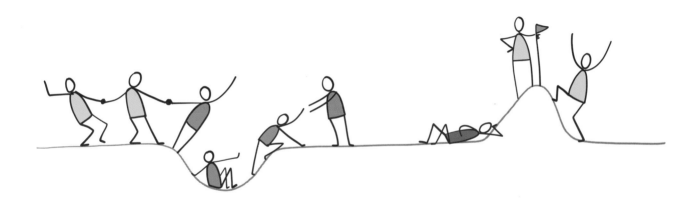

3.4 COMBINE ICONS

Your visual story starts with knowing broadly what to draw and the ingredients you need for this. Every story has a few keywords which capture its essence. These words are important because they are the ones you want to express in a drawing.

Sometimes a basic icon isn't enough to completely tell your story. The best thing to do in this situation is to search for a combination of icons which really convey your message. Write down a few keywords you would like to visualize and go to Google images. Type your word and add 'icon', 'vector' or 'illustration' to get more iconic images.

Every keyword will give you a selection of results. Keep on googling, combining and drawing.

AFTER THIS SECTION, YOU WILL:
- Know how to combine icons into a compelling visual, based on context and different angles of approach

Try to put these pieces together as a puzzle until you have a beautifully combined icon. This makes your story complete and unique! On the following pages you will find some great examples.

Tip: Save all your found or combined icons on your computer or smartphone, or make an analogue icon library in a special notebook.

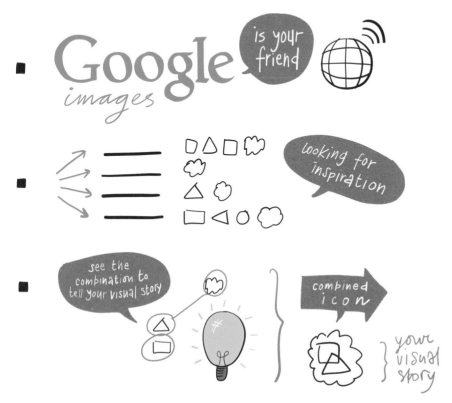

66

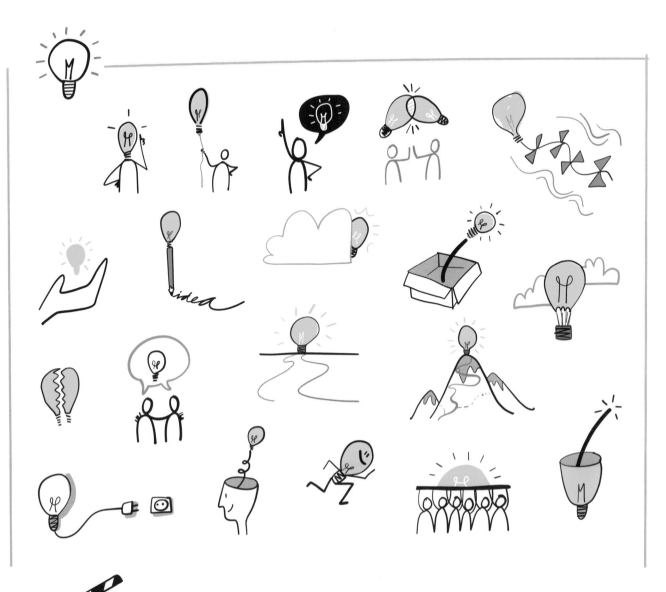

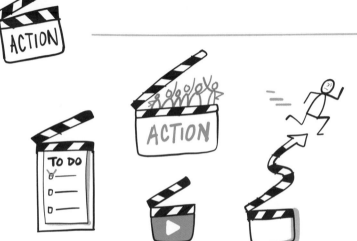

Tip: Be creative and don't try too hard to hold on to the original shape of an icon!

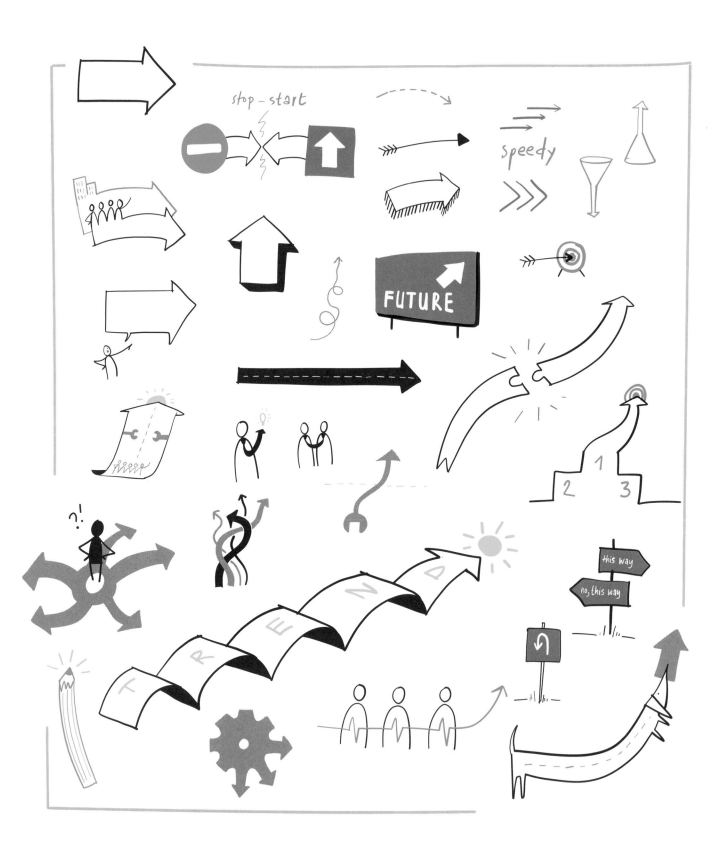

stop - start

speedy

FUTURE

this way

no, this way

T R E N D

1
2 3

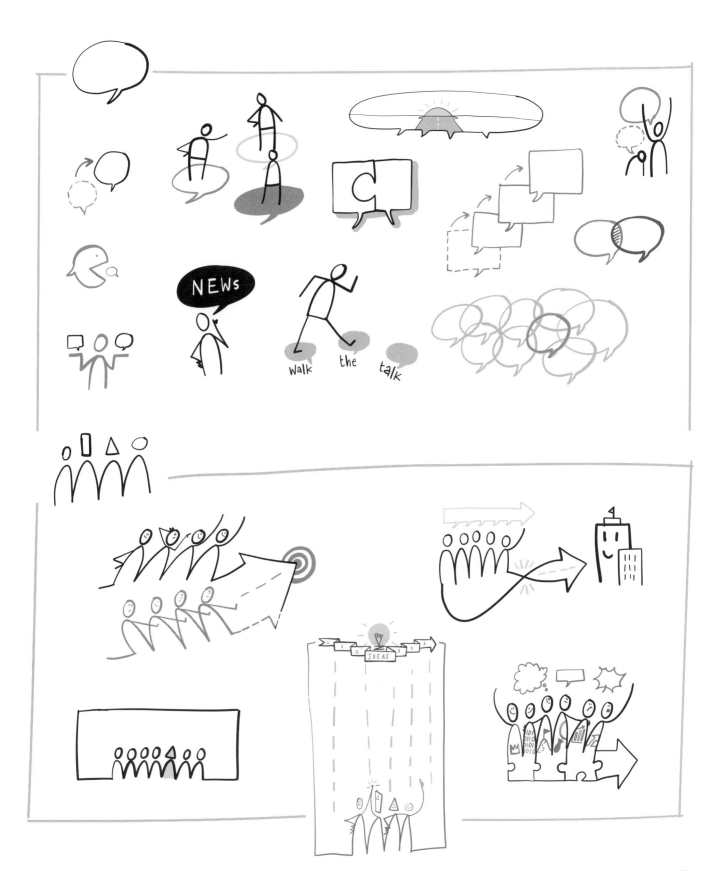

3.5 VISUAL VOCABULARY
THEME ICONS

AFTER THIS SECTION, YOU WILL:
- Know how to draw a lot more basic icons based on different subjects

From here on, we will give you some iconic examples, split into different themes. Get inspired and start copying or drawing your own thematic icons!

- Action!
- Scrum & Agile
- Ideas, Innovation
- Purpose finding
- Education, learning
- Resistance
- Internet of things
- Decision making

- Trust
- Implementation
- Various
- Group Dynamics
- Stakeholders

ACTION!

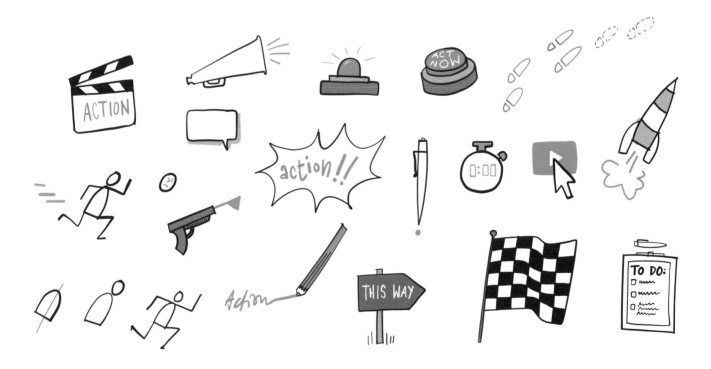

SCRUM & AGILE

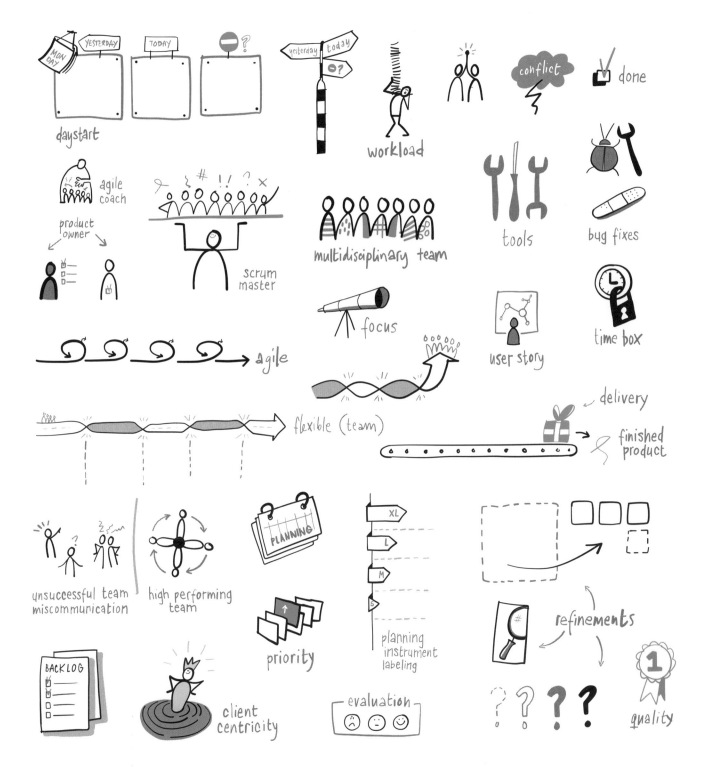

daystart

workload

conflict

done

agile coach

product owner

scrum master

multidisciplinary team

tools

bug fixes

focus

user story

time box

agile

delivery

finished product

flexible (team)

unsuccessful team miscommunication

high performing team

PLANNING

priority

XL
L
M
S

planning instrument labeling

refinements

BACKLOG

client centricity

evaluation

quality

IDEAS, INNOVATION

Tip: Broad terms like innovations are very hard to boil down into just one icon. In the previous section you have learned how to make combined icons for these terms.

NEW!

Vicky the viking

IDEAS

IDEAS

ideas

IDEAS

PURPOSE FINDING

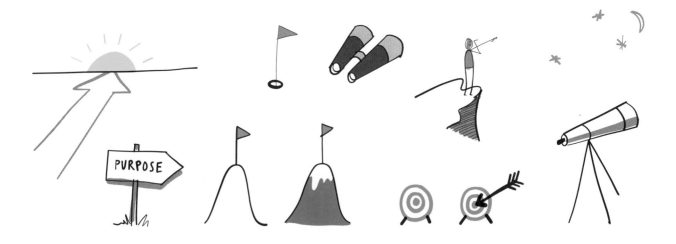

EDUCATION, LEARNING

intuitive ↗
intelligence

$$S = R^2$$

$$\sqrt{x} = 4$$

$$a + b = ?$$

RESISTANCE

INTERNET OF THINGS

personal call

chat

DECISION MAKING

IMPLEMENTATION

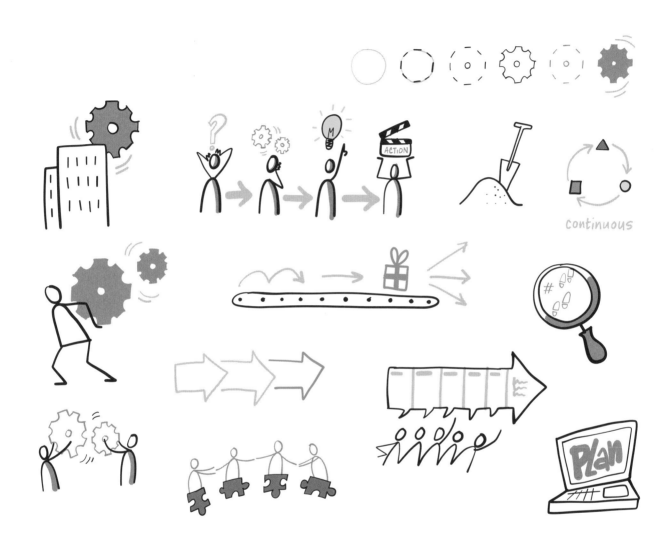

continuous

Plan

VARIOUS

Insurance

NEW

"dare to be different"

GROUP DYNAMICS

STAKEHOLDERS

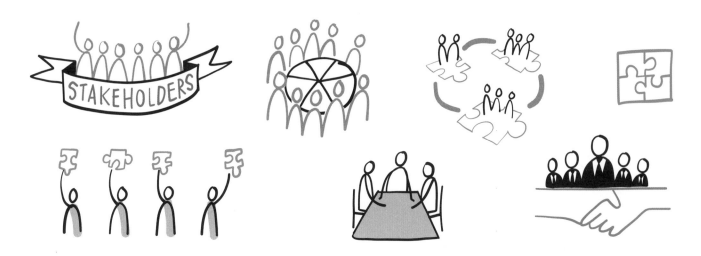

3.6 DRAWING INSPIRATION

AFTER THIS SECTION, YOU WILL:
* Know how icons and metaphor can work together in a visual

You've learned about icons and how to combine them. You also now know about hierarchy, color, setting up templates, etc. Here are some examples of the visual impact you can make when you weave together all those elements.

When we use text, we don't write full sentences. But without adding a few key words here and there, the visual would be hard to comprehend.

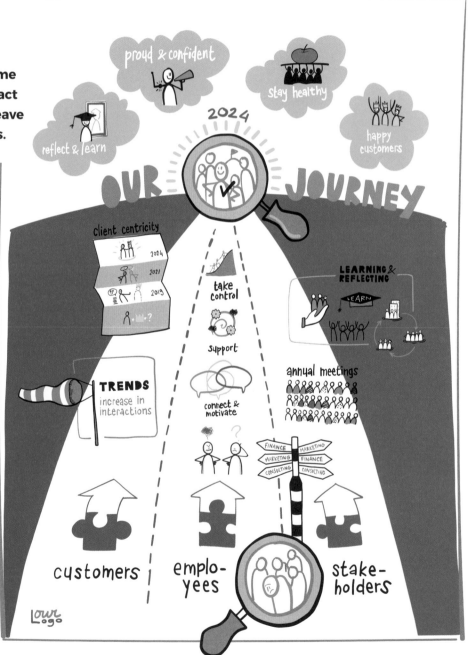

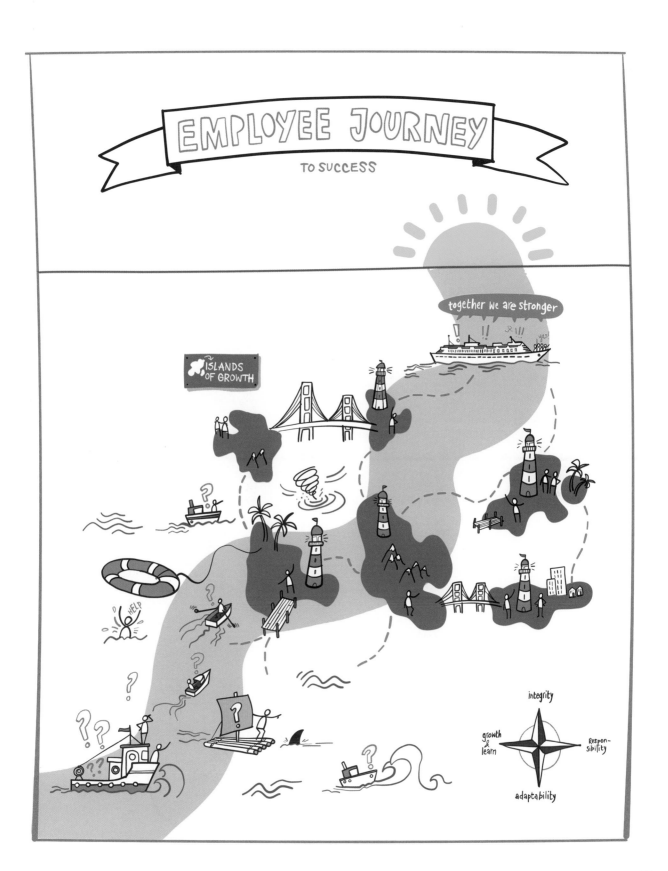

DAY-TO-DAY BUSINESS: ME

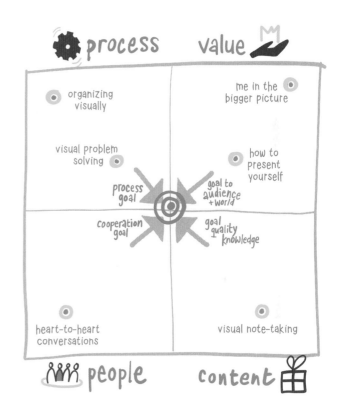

Now that we've covered the basics, you can get started with visual DOING in day-to-day business. Working visually within your organization starts with YOU!

Visual doing can power up your working life. Not only could using visuals in your job make you more happy, sometimes you just need more to have real conversations, see the bigger picture or solve complex problems.

Make simple beginnings. You'll discover that you only need to take a few small steps to start this transformation in your work life. Here are some key things we want you to learn:

4.1	**How to present yourself**	Stand out and present yourself visually
4.2	**Me in the bigger picture**	Find and follow your personal mission
4.3	**Visual note-taking**	Learn how to take visual notes
4.4	**Heart-to-heart conversations**	Use drawing to hold a meaningful conversation
4.5	**Organizing visually**	Get organized by visualizing processes
4.6	**Visual problem solving**	Use visual thinking to find (the best) solutions

4.1 HOW TO PRESENT YOURSELF

Do you want to raise your profile in your company or team? Would you like to present yourself differently? Or do you want to connect in a different way with (future) colleagues? Visuals are a powerful tool you can use as you draft your resume or introduce yourself to a team.

Where do you start?

What do you want to say about yourself? We like to make a personal pitch in terms of contradictions: Work vs. private life; now vs. the future (dreams and ambitions); things that energize you vs. things that put you to sleep; how you see the world now vs. how you want the world to be.

Elements you could include:

• Your name
• A self-portrait
• Dreams
• Ambition
• Qualities
• Skills
• Passion
• Mission

You could also use the model from our Visual Thinking book, section 4.1 'Sharing Your Passion' for input.

Visualize

You are the center of attention when you present yourself. That's why we mostly use a mandala or focus plan for this type of visual. But you could do something else. Try a passport, a traditional resume lay-out or an appropriate metaphor.

Tip: Section 2.4 (subsection 'Hierarchy how-to') gives an example of how to present yourself.

mandala focus

USE THIS WHEN:

• You want to connect differently with colleagues or your client
• You'd like to make a memorable first impression

Tip: Don't be afraid to show uncertainties or vulnerabilities. People will appreciate your courage and it could open up interesting conversations.

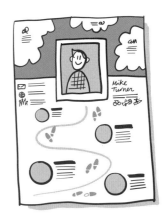

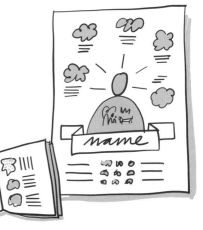

HOW TO DRAW YOURSELF

People think it's hard to draw themselves (or others). Trust us, it isn't! You just have to cut down on details: the nose, wrinkles (yeah!!), pupils, eyelashes.

Our step-by-step guide for the perfect self-portrait

- Start with a big U. Add your ears if you have short hair
- Where is the parting in your hair? Use it as a starting point and draw a line to the left and one to the right to show the inner hairline
- Now draw the outline of your hair emphasizing features like curls or waves
- If you have a short beard use dots (light, or gray!); if you have a fuller beard use thin lines
- Eyes are vertical lines
- Add a mouth – smiling!
- Now it's time for you body. This is another (bigger) U, but upside down
- A collar? Lapels? A pattern on a sweater? Draw them in – it makes a person more recognizable
- Write your name in your belly or as a header

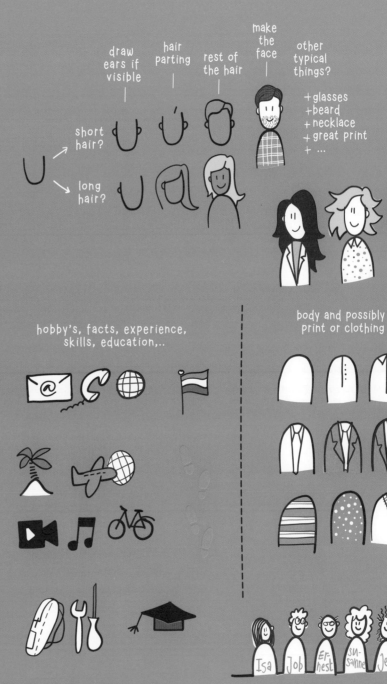

draw ears if visible — hair parting — rest of the hair — make the face — other typical things?

short hair?

long hair?

+glasses
+beard
+necklace
+great print
+ ...

hobby's, facts, experience, skills, education,..

body and possibly print or clothing

Isa Job Er-hest su-sanne Jess Tom

Tip: Draw your colleagues at the start of a meeting. You can use them as avatars on a kanban board.

it's great to start a meeting by putting your team members in a frame. Just add hair or other recognizable features to the body and head.

4.2 ME IN THE BIGGER PICTURE

When you imagine what you want to do when you grow up, you're influenced by people around you and ideas of how things are 'supposed to be'. But what path would you take if you were to follow, with self-confidence and creative courage, your true personal mission?

Imagine you're at a personal or career crossroad and want to find a new or logical direction or your next steps. Visuals help see the bigger picture of your life and possible new directions. Here's how you develop an overview of your bigger picture. This drawing lays out your personal dreams, mission, vision, the steps you might take and the doubts and

risks along the way. Looking at it you see where you need or want to go and it is easy to share this image if you want feedback.

Step 0 - Meaningful moments
On different pieces of paper, sketch highs, lows and turning points from the past. Hang them next to each other. Aim for about 4 to 8 drawings.

USE THIS WHEN:
- You want to dream up new directions
- You need to figure out the next steps in your (work) life

Meaningful moments from the past can teach us about the future.

Get inspiration by taking a trip down memory lane. Just scroll through your (phone's) photo library!

Step 1 - Me in the small picture
Start with a visual to characterize yourself. See chapter 4.1 for tips.

Step 2 - Create the big picture
Add contextual items (at the edges – they influence the vision). Where are the opportunities you want to work with? Where are the possible threats and how do you protect yourself from them without freezing?

Time for a break.

Step 3 - Fantasize & dream
Fantasizing will unlock a state of dreaming, then wishing, wanting and committing.

Turn on a relaxing playlist and fantasize how a beautiful day in 1, 2 or 5 years would look - personally and professionally. Collect visuals from (throughout) that day. Don't hold back on the number of images you use.

Step 4 - Create a hero image

Try to distil what you have come up with so far. It's time for another break.

When you return to the visual, create a hero image that can be hung at the end of the road on the horizon. It should be a single visual that inspires and energizes you to pursue you dream. It should be tightly focussed - the most essential visuals fit on a beer coaster.

Step 5 - Make a plan

Let's make this happen! Before shaping your plan, think of a metaphor. Having a metaphor for your journey helps to keep it alive, and helps you cope with unexpected obstacles or detours. Determine what's necessary to reach your goal. Certain skills/contacts/milestones? If this is too hard, at least decide on a possible first step that brings you a little closer.

Elements of the plan:
• Who/What?
• Why?
• Where to?
• How (as concrete as possible)?

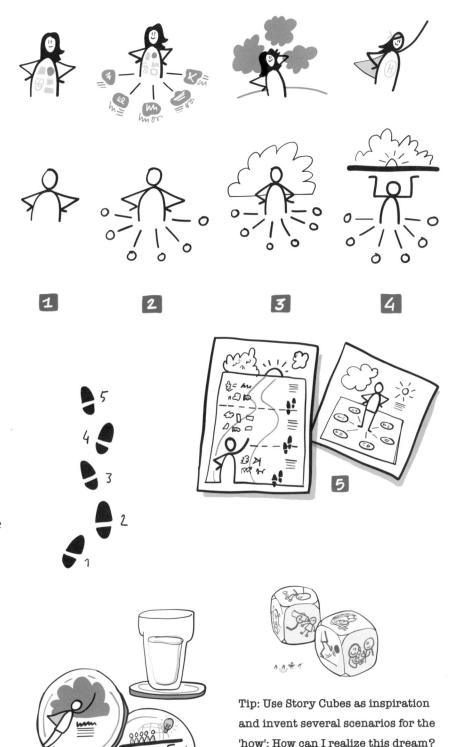

Tip: Use Story Cubes as inspiration and invent several scenarios for the 'how': How can I realize this dream?

85

4.3 VISUAL NOTE-TAKING

USE THIS WHEN:

- You want to listen more actively
- You want a visual record you can refer to later
- You want to capture a concept or idea

We do a lot of 'graphic recording', which means drawing live, on-the-spot, to create an instant visual snapshot of a meeting. There are a lot of different tactics to do this, but we especially love the simplicity of Eva Lotta-Lamm's '5 Steps for note-taking'.

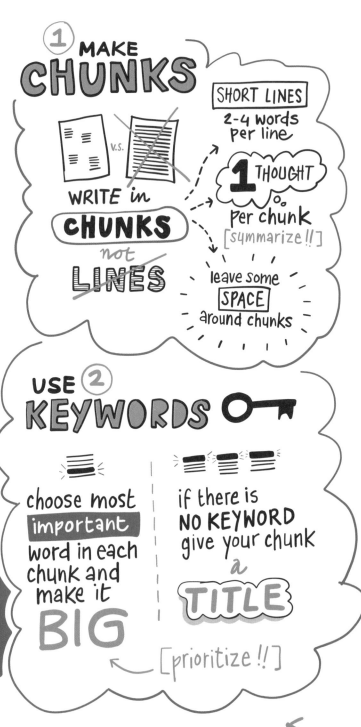

1 MAKE **CHUNKS**

v.s.

SHORT LINES
2-4 words per line

WRITE in **CHUNKS** not ~~LINES~~

1 THOUGHT per chunk
[summarize!!]

leave some SPACE around chunks

USE **2** KEYWORDS

choose most important word in each chunk and make it BIG

if there is NO KEYWORD give your chunk a TITLE

[prioritize!!]

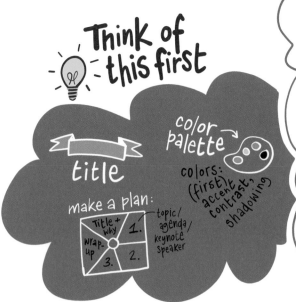

Think of this first

color palette

title

colors: (first) accent, contrast, shadowing

make a plan:

Title + why / 1.
wrap-up / 3. / 2.

topic/ agenda/ keynote speaker

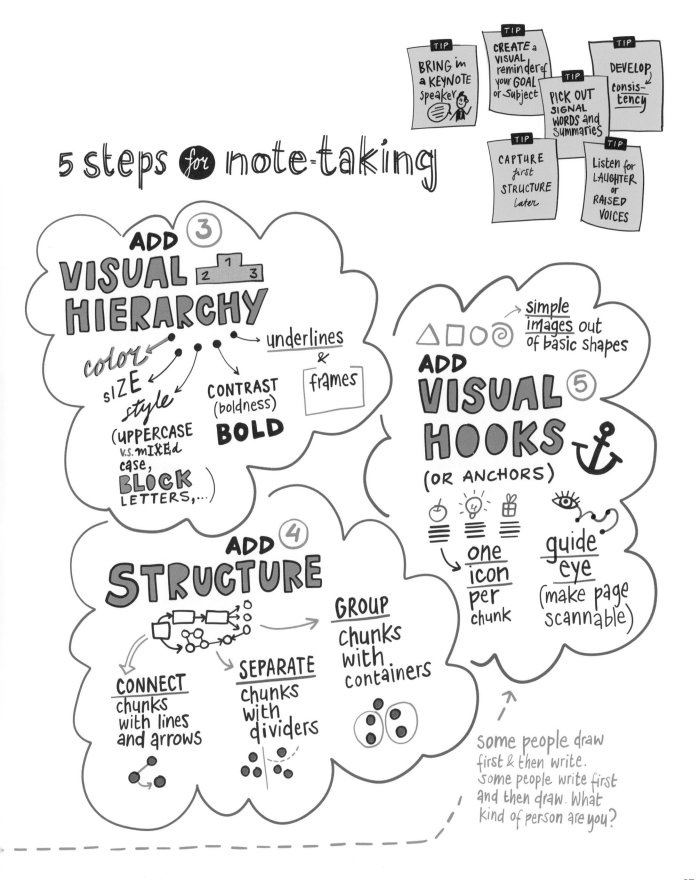

5 steps for note-taking

TIP BRING in a KEYNOTE speaker

TIP CREATE a VISUAL reminder of your GOAL or subject

TIP PICK OUT SIGNAL WORDS and summaries

TIP DEVELOP consistency

TIP CAPTURE first STRUCTURE later

TIP Listen for LAUGHTER or RAISED VOICES

ADD ③ VISUAL HIERARCHY
color
siZE
style
(UPPERCASE v.s. mIXEd case, BLOCK LETTERS,...)
CONTRAST (boldness) **BOLD**
underlines & frames

ADD ④ STRUCTURE
CONNECT chunks with lines and arrows
SEPARATE chunks with dividers
GROUP chunks with containers

ADD ⑤ VISUAL HOOKS (OR ANCHORS)
simple images out of basic shapes
one icon per chunk
guide eye (make page scannable)

some people draw first & then write. some people write first and then draw. What kind of person are you?

4.4 HEART-TO-HEART CONVERSATIONS

USE THIS WHEN:
- You want to connect on a different level with colleagues or clients

Images take us to a more emotional level. We experience this every day. Using a drawing to help discuss an issue makes it much easier and less tense or threatening to take talks to an emotional level.

How do you use visuals as an easy and engaging way of taking conversations to a deeper level – not just in terms of the topic, but to bring participants closer together? Not just in terms of the subject, but emotionally.

A way of communicating that builds bridges and creates more integrated and sustainable conversations.

Why drawing helps
- It makes a conversation less confronting. You won't be looking at each other all the time. Instead, you'll be looking at the drawings together.
- The drawing provides starting points to ask questions, whereas a spoken conversation is often a series of reactions to what your conversation partner just said.
- When answering a question in drawings instead of words, you tap into feelings. You 'think with your hands' and choice of words or grammar don't cause any barriers.
- When you take the time to answer questions in silence, by drawing, you stay focused on what the question real-

ly means to you. In spoken conversation, the answer can be influenced, remain superficial or a dominant person can steer the conversation away from the question.
- In a conversation we tend to withhold certain comments. We think it isn't important, it's scary, or we simply forget.

When to use drawing
- To connect or get to know each other
- To give or seek feedback
- To discuss progress in a project
- To discuss developments
- For problem solving
- To resolve or discuss conflicts
- To outline a problem
- To share information
- For interim evaluations

What else can you think of?

How to use drawing

1. By using a template and filling it together during the conversation, or on your own ahead of time.
2. Let the other person draw, and/or make a drawing yourself. Discuss the outcomes.
3. Literally draw together, by each working on the same drawing, one after the other.
4. Draw live, on-the-spot, during a conversation. To help explain your point, to show how you feel or to note the outcomes.

Note that not everyone is ready for a heart-to-heart conversation. Don't make this the sole purpose, it's about having a good, meaningful conversation that brings you closer together.

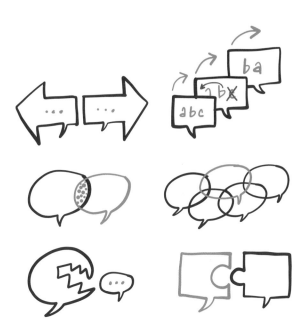

How to decide what approach best suits the conversation you're about to have? Ask yourself the following:

1. WHO AM I TALKING TO AND WHY?

2. WHAT IS THE AIM OF THE CONVERSATION? WHAT RESULT DO I WANT?

3. DO I WANT TO CONVEY OR GATHER INFORMATION, OR DO I WANT TO BUILD BRIDGES?

4. WHAT DOES THE OTHER PERSON EXPECT?

5. ARE THERE RELEVANT ISSUES THAT COULD AFFECT THE OTHER PERSON'S ATTITUDE?

6. TO WHAT EXTENT CAN I, AND DO I WANT TO, TAKE THE LEAD?

7. IS IT GOING TO BE A TOUGH DISCUSSION? WHAT ARE THE POSSIBLE SCENARIOS?

8. TO WHAT EXTENT DO WE AGREE WITH ONE ANOTHER?

9. DO I WANT TO BE FULLY OPEN, AND HOW OPEN CAN I BE? — a precondition if you expect this from the other person.

4.5 ORGANIZING VISUALLY

This paragraph helps you organize your day-to-day work life; the projects you work on, information that is relevant to you and work processes that are your responsibility.

Before we start, we understand that every person is unique and we strongly recommend that you find your own best way of organizing. We also know that people have different brain styles that can be taken into account when organizing.

We differentiate

- Analytical types, who like facts and information
- Innovative types, who like ideas and adventure
- Social types, who like people and connections
- Implementing types, who like getting things done

How we organize

1. Collect and visualize: arrange
2. Play and structure: uncover logical links
3. Order and prioritize: know & define
4. Put in time/keep track

USE THIS WHEN:

- You want to create a clear overview
- You want visual structures to help gain insight and understanding
- You want visual, physical reminders to maintain focus

Tip: make use of symbols and structures that fit your brain type. Or the brain type of your audience.

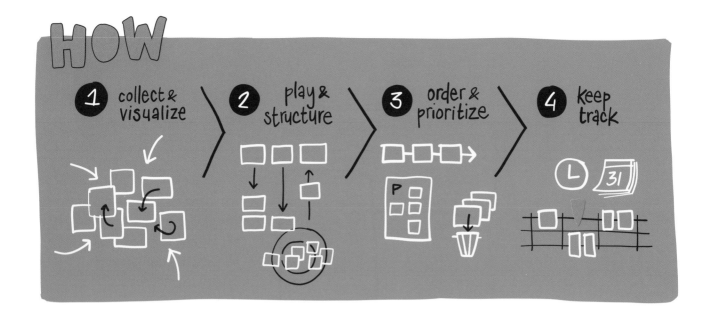

What we organize

 A PLANNING

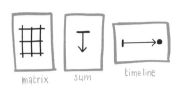

matrix sum time line

Time is often the starting point; our goal is to make optimal use of time as we plan what we want to do and who we are going to meet.

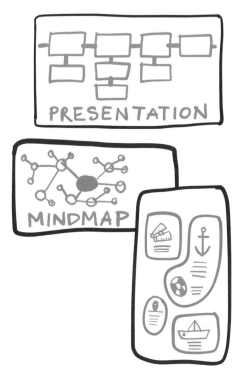

PRESENTATION

MINDMAP

 B INFORMATION

mandala matrix

We organize information or knowledge to understand it more deeply and see new connections between different pieces of information or knowledge.

C 🎯 PROJECTS

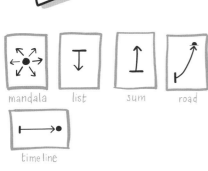

mandala list sum road

time line

Projects have a specific goal or result and a limited time frame. The goal or desired result is the starting point. We aim to create an overview of resources, qualities and time that helps us keep track of the project and deal with changes.

RESULTS

START

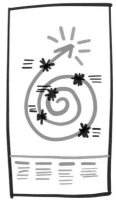

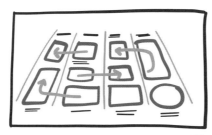

TITLE

D PROCESSES

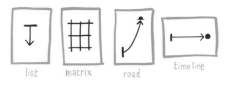

list matrix road time line

Processes are defined by cycles: Like a project, a process has a beginning, middle, and end. However, this cycle repeats itself over time. Our aim when we visualize a process is to either gain insight on how a process runs (and how we could run it more smoothly or efficiently) or to clarify the process for all stakeholders.

Boost
visual

Courage

4.6 VISUAL PROBLEM SOLVING

Although many people like to say: "I don't see problems, I only see challenges!", the reality is that we encounter plenty of problems in our lives. This section helps you solve these problems in a visual way. Next to already well-known marketing/strategy models and our own experience, we have been inspired by Dan Roam's book "The Napkin Unfolded" and "Problem Solving 101" by Ken Watanabe.

Why solve problems visually

Visuals not only help to deeply understand a problem and find the root cause, they also stimulate us to look at our problems both rationally and emotionally. To solve problems we use writing, drawing, visual templates and visualizing solutions to reach the right decision.

Don't jump to solutions

When we're in visual sessions with our clients and a problem occurs, it strikes us that people want to immediately come up with solutions. We – as people - just don't seem to like having problems. So we try to solve them as quickly as possible. Unfortunately that often fails to tackle the root cause. Problems keep coming back (sometimes worse, or bigger). So don't jump to solutions. Instead you're better off taking the time to dive deeper into the

USE THIS WHEN:

- You don't want to jump to conclusions
- You are wondering how the four steps of problem solving would work visually
- You want to try a different approach to problem solving: a visual approach

problem, find the root cause and make a deliberate, well-advised decision on how to solve it in a structural way.

FIND THE PROBLEM

Step 1 - Visualize the problem
We start by visualizing the problem to deeply understand it.

1. Use the questions: Who and What, How much, Where, When, How and Why? Work out the nature of the problem. Just use your instinct.

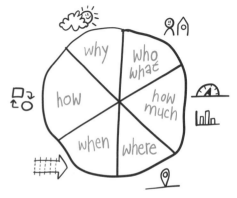

every problem has its own pizza
—by dan roam—

MY PROBLEM

2. Come up with a first symbol for the problem, and explain the problem in a simple way (the way you might explain it to your child).

3. Now write down a couple of Who, What, How much, Where, When, How and Why questions. Color the top 3 or 5 questions for the next step.

4. Draw the answers to the colored questions using Dan Roam's pizza as a hint for what you could draw. Look at your drawings. Do they make the problem clear? Work until you have caught the entire problem in drawings.

5. Draw a logical overview of the problem (in a simple, symbolic way)

Step 2 - Finding the root cause
To find the root cause we use a 5*WHY template and/or a root-mindmap.

1. Make two drawings of a question mark divided into 5 areas. From the top of the question mark down, answer these questions 5 times in a row:
 - Why is this a problem?
 - Why does it occur?

2. Take a big sheet of paper; draw and write down the problem in the middle of the paper. Imagine that this is the trunk of a tree, seen from above. Work from the inside out to create a root-mindmap of possible causes. Every cause is a branch from the root. Work through all causes until there are at least two 'layers' of causes (with a minimum of 2 root causes for each cause). Create symbols or small drawings for the root causes that seem to be important.

3. Now draw a list of the top 3 or 5 most likely root causes. Give the list a short (working)title.

For a small or medium-sized problem you can skip some of the (sub)steps.

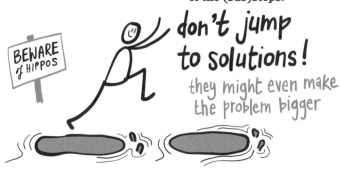

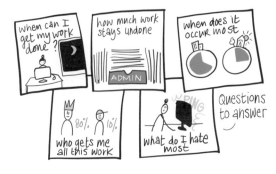

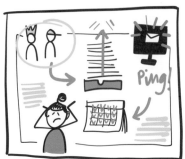

problem overview

SOLVE THE PROBLEM

Step 1 - Different perspectives

Even once we've identified the most likely root causes, we still don't want to jump to solutions. To find solution ideas, we have to look at the problem from different perspectives. Three ways to do this are:

- Take the drawn list from the previous step ('Find the problem') and rephrase them as solutions. For instance, if the root cause is "we didn't take the time to explain to our audience the value of visual thinking", we might rephrase this to the solution: "we should take time to explain to our audience the value of visual thinking".
- Write down or draw the problem on a piece of paper and divide the rest of the page into four quadrants. Each quadrant is for a person(a) you think can help find solutions for your problem. Draw the personas (or heroes, idols) and think of a few characteristics for each of them. For instance; Pippi Longstocking who says: "I have never tried that before, so I think I should definitely be able to do that". Now make notes on how these four people would solve your problem.

- Take four pieces of paper to find solutions by looking at the problem from different perspectives:
 - From above (a helicopter or bird's-eye view)?
 - From the front (a dog)?
 - From far, far away?
 - From really close (a fly)?
- Now see if you find new solutions from these perspectives.

Step 2 - Pick a solution

To select the best solution, sometimes you just have to look at all the options and suddenly it strikes you: you know exactly how to solve the problem! If you still need to give it more consideration, plot your solutions and ideas on a matrix. See 5.4 Select and eliminate, "Select ideas" for a walk-through. Feel free to choose different axes, i.e. 'impact' and 'effort'. Pick the best 2 or 3 solutions and visualize how your path to solving the problem will look for each solution.

KICKSTART

5. DAY-TO-DAY BUSINESS: WE

Inspire and be inspired by co-creating. In this chapter we present tools and visual techniques you can work on with your team, department or another group.

Once you've started drawing, you will realize that collaboration with your colleagues would improve if they were drawing, too. You'll have more fun, your meetings will be more focussed and reports more concise. You can learn together; share, build, decide and connect. This is where things start getting interesting – and effective! In this chapter we will show you the following visual techniques:

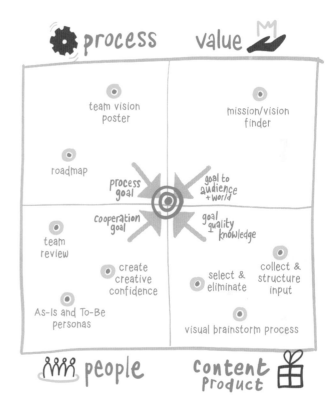

process value

team vision poster

mission/vision finder

roadmap

process goal

goal to audience + world

cooperation goal

goal quality knowledge

team review

create creative confidence

select & eliminate

collect & structure input

As-Is and To-Be personas

visual brainstorm process

people

content product

5.1 CREATE CREATIVE COURAGE

Have you ever struggled to get a group of people into a creative mindset? How to instil in them the creative and visual courage to tackle a task? Maybe you want to encourage them to pick up a pen and draw or to visualize a concept or explain it using a metaphor.

In this section we will give you tools to get the creative juices flowing. These easy exercises will unleash energy and boost co-creation.

USE THIS WHEN:
- You want to warm up a group before a visual session
- You want to put people in the right frame of mind before a brainstorm

INTRO TO DRAWING

If you want participants in a meeting to draw along with you and work together to create a visual, it's best to start with a brief introduction to drawing (unless they've already had a visual thinking/ drawing workshop, of course).

Tip: If you want to make your introduction a little more comprehensive, you can teach people how to work with different markers (explained in our book 'Visual Thinking') or draw some basic icons together with the group.

some basic icons:

individual team

processes company

delivery focus/analyse

Step 1 – Inspire
Explain the power of visual thinking and stress that everybody can draw: If you can write, you can draw.

Step 2 – Copy
Have them pick up a black marker and simply copy what you do. Start with a 'U', draw a 'Z', put an 'M' on top and finish it off with an 'O'. The result will light up their creativity.

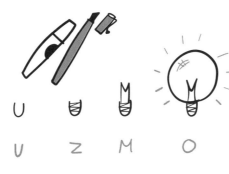

Step 3 - Next level
If you want, you can also do VOICIS with them (from page 58 of this book).

NEW PRODUCT IDEA

To open up people to new ideas and unexpected solutions, give them all a blank piece of paper divided into three (by vertical lines) and a marker.

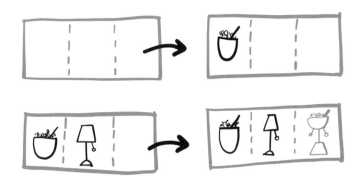

Step 1 - Breakfast detail
In the left hand column, have people draw an element of their breakfast.

Step 2 - Beloved furniture
Pass your drawing to your neighbor on the right. Then have them draw their favorite piece of furniture in the middle column.

Step 3 - Combine
Pass the drawing on again. In the righthand column, combine the two previous drawings into a new product.

Step 4 - Share
Have fun listening to all the crazy and original ideas people came up with!

Be creative: Think up your own categories for the first two columns.

UNEXPECTED COMBINATIONS

Trigger even more out-of-the-box thinking and generate creative ideas without dismissing them as 'not feasible'. Unlike the previous exercise, which is all about collaborating, this one makes you mine your own mind for new ideas.

Blend the boxes
Fill in the matrix and combine both visuals to create something new.

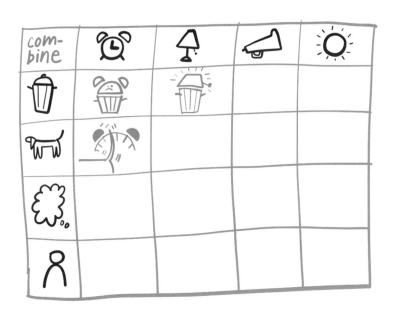

THIRTY CIRCLES

We have borrowed this exercise from the book 'Creative Confidence' by Tom and David Kelley. It aims to kickstart creativity and to explain the balance between fluidity and variety when brainstorming new ideas or solutions.

Step 1 - Thirty circles
Ask people to draw thirty circles on a blank piece of paper. They should be the same size and not overlapping.

Step 2 - Create
Give the group 3 minutes to turn as many of the circles as possible into a recognizable drawing.

Step 3 - Share & Compare
When the 3 minutes are up, discuss how easy or difficult it was. Did anyone 'break' the rules by combining several circles into drawing? And was this even a rule or just an assumption?

If there are people who have finished a lot of circles, but many of them are in the same category (e.g. a baseball, a tennis ball, a soccer ball, etc.) you have low variety. If someone drew good, distinct pictures but only finished a handful of circles, you have low fluidity. You could play with these two parameters to find a balance and produce a rich set of ideas or concepts.

SQUIGGLE BIRDS

To demonstrate our ability to visualize and create things that are not (yet) there.

Step 1 - Squiggle away
Ask people to take a colored marker and draw six random squiggles on a blank piece of paper.

Step 2 - Make birds
Once you've drawn your squiggles, turn them into birds! Take a black marker and draw beaks, eyes, legs and if you like, a wing or tail.

Look at your drawings. What do you see? What is actually there?

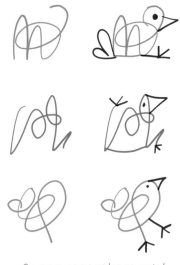

Source: www.xplaner.com/
visual-thinking-school

ABSTRACT DRAWING

undercurrent

As you've seen, we mostly use visuals people can easily recognize as something from the 'real world': People, animals, buildings, processes, positions on a map.

But deliberately drawing in abstract shapes and colors can also be very effective. Drawing abstractly means you don't have to worry about how something 'should' look. Instead, thinking and drawing happen simultaneously.

This is particularly suitable when discussing abstract issues like feelings and emotions that can form an 'undercurrent' in a team or organization.

Example
In this visual work form we have a meeting to openly discuss how a team is performing.

Materials
- 1 or 2 blank sheets of paper
- Tape
- Markers

Setting
Standing up. You don't want people sitting comfortably in their chairs! There is a blank piece of paper for everybody on the wall or window.

Action plan
1. Warming up; draw squiggle birds.
2. Ask everybody to stand up and tell them their hands will be doing the work, then ask your question "(e.g. Visualize how you experience the cooperation in your team)". People are only allowed to draw abstract forms. Give them five minutes so they can slow-ly draw (articulate visually).
3. What have they drawn? Can they explain it? What do others see in it? Discuss with your neighbour.
4. The group can then share their experiences. Do people recognize themselves in the drawings or explanations? Ask open questions and allow the discussion and drawings to develop within the team.
5. End the meeting by thanking everybody and asking what the exercise meant to them. You could also draw a visualization of what the team wants to achieve.

5.2 VISUAL BRAINSTORM

A brainstorm is a great way of challenging our intellect and pushing our (collective) imagination to the limits. But it can produce so many ideas that concepts become fuzzy and abstract and we risk missing key insights.

Visuals help to isolate and share insights and enable participants to further explore and combine ideas. They work on different levels. Sketching and doodling ideas helps to clarify them and can stimulate other participants' imagination. Only part of your brain needs to focus on how to draw the idea; the other half is subconsciously looking forward to the next step, the next idea.

In a broader sense, a good visual template can organize input and generate specific results linked to the original concept.

USE THIS WHEN:
- You want to generate more than just the obvious ideas

QUESTIONING

Before you start, define a relatively concrete problem that does not leave too much – or too little – room for discussion. If you are too vague, you run the risk of equally vague results that will not give you anything to work with.

If your question is too focussed, you make it difficult for people to think outside the box and come up with unexpected responses.

We often begin with "How might we..". This kind of open question serves as a frame to spark ideation and innovative thinking. A question could be: 'How might we deepen the trust within our team'

Tip: If you want to collect input beforehand from people who are not attending your meeting, you could use the heart-to-heart conversation template from chapter 4.3. You could also install an old-fashioned idea box, or think of a setting where people can answer questions or ideate without you having to be there to coordinate or explain.

CARD MAPPING

Write each of your ideas or thoughts on a different post-it or card (roughly the size of a post-card).

But don't just write; draw on each card, too. This will make each card distinct and let you see at a glance what it is about. An icon is enough and draw only in black (with gray, if you like). That makes the process quicker and prevents any one card standing out too much.

Tip: Preprint your cards with a section to write and a box where you can draw, so people don't forget to use both text and visual.

When card mapping, start individually. After about 5 minutes, have everyone share their ideas or create an overview of all the cards so people can see and discuss them. You could vote on the ideas, and let subgroups work on new iterations based on the ideas.

SILENT BRAINSTORM

This exercise involves a group of 3 to 12 people drawing silently – not writing.

Start by writing a question at the top of a blank sheet of paper. When the exercise begins, draw an answer or idea on the paper. After a minute, pass your paper to the person sitting to your right and repeat. Keep repeating the

process – in silence - until each participant gets back their original question with drawings from the whole group.

The power of doing this without speaking or commenting is that you can fully engage in associative thinking, and elaborate on what you have in front of you.

When you have your own drawing again, look at it and try to be open about thoughts, ideas and solutions that pop into your head. As a group you can either choose to stay silent (and let people interpret the drawings for themselves), or you can ask questions about the meaning and thoughts behind some of the drawings.

You can do this with words too, by starting a mind map about a certain subject or question. Pass it on and elaborate on the mind map from the person before you.

BRAINSTORM TEMPLATES

Explain context with a visual (metaphor) and use this in a template to collect specific ideas. This way, working visually can guide you through a brainstorm.

Let's look at the tree metaphor: Goals could be apples, and they can be categorized in high-hanging and low-hanging fruit (ripe and not yet ripe). We can't influence all external threats such as bad weather, but we can brainstorm on how to cope with or prepare for them. A saw could be a threat we can influence, or represent competition. Brainstorm how to deal with certain situations or opportunities that could arise.

The templates can be drawn on a big sheet of paper, but can also be printed on smaller paper so people can work on the problem in pairs. You can also distribute templates via email.

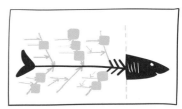

VISUAL STIMULI

If a group is stumped for new ideas, or going down the same predictable paths, try to spur their creativity by brainstorming using visual association.

Go to Google Images or a stock photography website and enter search terms related to the brainstorm. You could also randomly pick another object, word or image, either physical or digital. Looking at images or artwork can activate other parts of your brain and help formulate new connections in your mind.

Select an image and imagine how you can fit it into the situation you are discussing. Once you have an object, try identifying its characteristics: Is it hard/soft/bright/ childish? See what happens when you use these concepts in your brainstorm. If there are people in the picture, ask the group: 'How would this person feel or think about the problem?'

Visual Meetings

6 tips to make your meetings

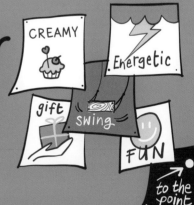

CREAMY
Energetic
gift
swing
FUN
to the point

1
DRAW the agenda & use a metaphor for the attendees to relate to.

AGENDA

2
make visible if you are diverging or converging

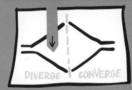

DIVERGE | CONVERGE

3

make use of visual canvasses to engage attendees and to collect input

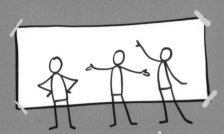

4
use a BIG surface for BIG ideas or to give an overview

5
'force' & inspire attendees to draw their input or to fight out disagreement by drawing

6
make visual notes (to be able to move on after a topic has been addressed)

5.3 COLLECT AND STRUCTURE INPUT

Collect and structure focused input in a meaningful session, to gain insight, overview and to include everyone's ideas.

Do you want to know where the group stands? Are you looking for input to help build on your idea?

Are you looking to tap into other people's expertise?

For this, we use simple templates. Once you see how easy this is, you can make your own!

USE THIS WHEN:
- You want to include everyone's thoughts and ideas
- You want an overview of everyone's input

STOP-START-CONTINUE

This is a group activity that can be used to solve problems, agree on change and develop strategies to achieve it. It is often used to address behaviour within a group or company.

What new strategies can be used? What needs to stop? What is going well and should continue?

Divide a sheet into three columns with the headings Start, Stop and Continue. Under each heading, write down themes, issues and actions that will help change the way a group works.

Over time, the content of the columns should change to adapt to new dynamics and challenges.

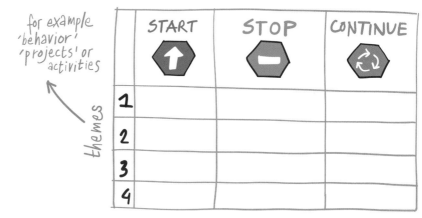

Source: Bob Tiede - leadingwithquestions.com

TWO SIDES

This is really just a sheet or matrix listing plusses and minuses, pros and cons. A visual template really can be this simple!

To gather quick feedback or input, just think of a useful pair of contradictions such as -/+, yes/no or helpful/harmful. Draw them at the top of a big sheet divided into two halves by a vertical line and ask people individually to write down what they think are the pros and cons of a particular idea or plan.

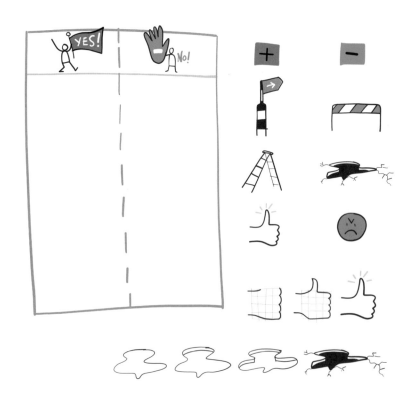

MATRIX

A few more examples of matrices and input/activation templates. Make sure titles are supported with icons or visuals and think of how best to use color (coding) and post-its.

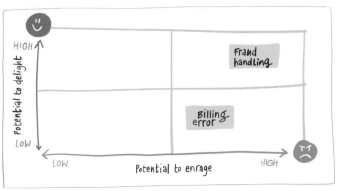

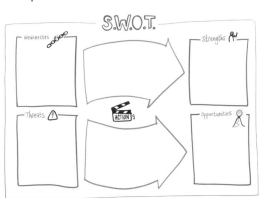

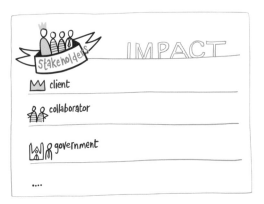

STICKY NOTES

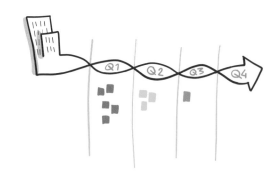

Simply by drawing several headers with questions or subjects you're interested in you can invite people to provide input by writing or drawing on sticky notes. Make them as concrete as possible, so the input can automatically be bundled in a convenient way.

Headers should be clear and speak for themselves so people can roam around the room and provide input without you having to constantly interrupt to explain things.

You can let people color-code their answers with post-its, too. For example, you could use pink post-its for negative answers and green ones for positive responses.

cluster! and put main topics on top

Indeed, colors or shapes of sticky notes can play an important role in the process. It sounds obvious, but imagine the time and effort you will need to order, structure and categorize people's input if you are working on several different flips and everybody in the group is using the same color sticky notes. A quick recap of all the new insights will not be quick at all!

Things to keep in mind

1. Link headers using colored sticky notes.
2. Have the group use thick markers and few words to write on sticky notes.
3. If clusters of sticky notes form, make sure that the note at the top has large, clear letters; this creates an obvious visual hierarchy.
4. Think in layers and frames. Using a thick marker, you can draw a big circle around a cluster of sticky notes.
5. Have you seen black sticky notes? Use them with a white marker (see Chapter 1) for a perfect combination to give a cluster a title. They really stand out!
6. Having trouble making a choice? Try dot voting. We explain how in the next section.

5.4 SELECT AND ELIMINATE

If you have a lot of input, you need to structure it. This makes it easier to select the ideas you want to focus on and eliminate the rest.

Once you have gone through this process of elimination, you can think of how to prioritize or visualize the input you have decided to focus on and consider what action is needed and in what timeframe. We have done something similar in the 'Making Plans' case study in chapter 6.

We assume you have already collected the information. So let's now look at how to select and eliminate the input.

USE THIS WHEN:
- You need to narrow down a lot of input

THE FIRST CUT

Materials:
- Big sheets with "NO", "YES" and "MAYBE"
- All your input on separate cards

First cut
This phase is especially useful when you have a LOT of input. Make three stacks labelled 'YES,' 'NO', 'MAYBE' and divide the input-cards quickly.

A couple of possible criteria:
- Is it possible to achieve (in the chosen timeframe)?
- Is it in line with our mission/vision/BHAG/..?

You want the whole group to agree on these choices. Once you have, set aside the stack labelled "NO." Merge and continue with the "YES" and "MAYBE" stack.

There are a couple of things you can do, depending on your situation and goal. Read on for our suggestions.

DECIDE WHAT TO FOCUS ON

Materials:
- Different colored papers
- A big room
- All your input on separate cards

Overview

Lay each idea on the floor or on a big table (in no particular order) so you have an overview. If there are cards with nearly identical ideas or cards that clearly belong together, assemble them together.

Card sets

Time to dive in! Arrange your cards into sets. When a set of cards crystalizes into a clear idea or theme, give it a creative or metaphorical name (e.g. "work in the garden"). Use the different colored sheets of paper to write down the names of your collections. Try to have no more than six themes.

You could do this as one group or split into smaller groups working in different parts of the room. After 10 minutes, they could switch seats so they build on each other's sets.

On the scale

Think of a good scale on which to plot your elements and create or imagine this scale (a line) on the ground. The right side could, for example, represent "crazy, ambitious or challenging", the left side could represent "easy or boring".

First, have everybody stand somewhere along the line, where they feel comfortable. The goal of this task is to get an idea of what people consider realistic or challenging.

Secondly, ask the group to plot the cards on the line. Do it by theme to maintain order in the chaos.

Ask everyone to pick up one card which would make their heart beat faster if it were to be achieved in the coming year(s), and two cards that they (and their team) want to take responsibility for and bring to fruition. Have the group share the reasons for their choices.

Tip: take a picture of all the input laid down on the floor.

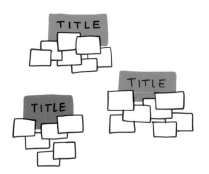

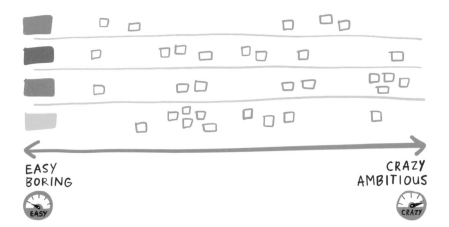

EASY
BORING

CRAZY
AMBITIOUS

SELECT IDEAS

Materials:

- A big enough wall or room
- Two kinds of stickers
- Framework of feasibility
- All your input on separate cards

Dot voting

Once you have laid down all the different input cards or post-its, or stuck them on a wall, give each member of the group six stickers - three of each kind. In this example, they are green and orange. Blue represent 'easy' and orange is 'interesting'.

Ask people to stick them on whichever post-its or cards they want. Do this in silence so people can focus on the post-its.

Plot your input

On a wall, make a big matrix with motivation on one axis and ability on the other. Plot all the post-its that have stickers on them on the matrix. Make sure the whole group agrees with the locations.

The post-its located in the upper right section of the matrix are the ones that will be most interesting to proceed with.

Dot voting can also be used as a working form on itself.

Next steps

You can draw a (diagonal) line somewhere along the matrix and choose to only continue with input that is located to the right of this line. You can also let the group decide where to draw the line.

Now you have plenty of choices, depending on your situation, the input and your goal.

If the input selected are, for example, actions that you want to get done in the upcoming year, you can now plot these elements on a timeline and visualize a plan.

If this is part of an inspiration session you can ask the group to pair up, take three things from the matrix and come up with a concept based on a combination of these three things.

Give the concept a title. Explain why it solves the problem and write down key words. Above all, visualize the concept and make a storyboard.

5.5 TEAM PERFORMANCE

Is your team not working well together? Are agreements about mutual feedback running into opposition? Are some issues being avoided? Or do you want to make your team work even better? Do you have the ambition to develop into a high performance team?

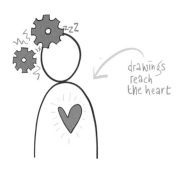

drawings reach the heart

We find that if you regularly carry out team reviews visually, the process is less confronting. Words can get into people's heads, drawings touch their hearts. People can't get angry at drawings.

Using drawing and images also engages different sections of the brain so that people think in terms of solutions, not problems. The right half of your brain compares, divides, sees consequences, thinks of problems. The left half doesn't make comparisons; that enables people to think about possibilities.

Benefits of a visual review
- It's inclusive: Everybody's opinion matters
- It's a stimulating way of working that people enjoy repeating
- It's more efficient. People need fewer words and are more quickly engaged by drawings at subsequent meetings
- It's fun!
- It brings people together and fosters mutual understanding
- It fuels shared ambition
- It clarifies team dynamics and allows you to share feedback faster and more frequently

Subjects to share and review with your team:
- Best practices
- Strong initiatives
- Motivations
- Feedback

BENEFITS

USE THIS WHEN:
- You are looking for inspiration and examples for various team meetings

On the next page you'll find templates and exercises you can use in team reviews. Take the time to do them with your team or use them as inspiration and design your own.

AVATARS

do you have awesome hair?

mo

DAVE

rose

lefty

rick

Ismael

CORE VALUES

Do you want your team to feel aligned in striving for the same core values? Or do you want to reach the same goal by taking different paths? In that case, it's important to clearly define those values.

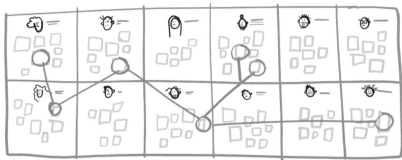

exceeding customer expectations

putting the customer first

deliver exceptional results

achieve more together

being accountable

professional

socially responsible

integrity

result driven

always being respectful

Step 1 - Collect values
Collect, visualize and/or write down possible team values.

Step 2 - Connect the dots
Are there common values? Connect the dots, discuss and agree on a top 5.

CORE VALUES team members

DEFINITION OF AWESOME

Create a definition of awesome by asking the team: 'What would our ideal world look like?' Describe the next target condition you want to reach. This is the first realistic goal on the journey to becoming awesome. Identify the first possible steps you can take as a team to reach the target condition and decide on frequency of follow-up discussions.

AWESOMENESS

FIRST STEPS

THE FIRST REALISTIC GOAL

ROUTE X

Tip: If your goal is not yet clear, sketch your template in gray or leave blank space so you can add information together.

DREAM CATCHER

This work form will help your team to dream what it could achieve. It catches dreams as well as nightmares.

You can start or even finish by identifying where you think the team is now. Fill in this model together. Use the different levels to guide you in considering your next steps.

Note:
It's not always a good idea to fill in the negative side of the pyramid. If a team or organization is not functioning well, this could cause too much stress.

Example on the right: A team of editors at a magazine publisher. They were doing great, but they have to shift their focus from print/offline to online.

Express yourself in clear and concrete terms as you fill the template with text and images. Think up metaphors and icons for each level. You can use these again in subsequent discussions without having to explain all over again what you meant to say.

How to fill in the pyramid of awesomeness:

3. Wow, win! If we achieve excellence, awesomeness. We're ecstatic!
2. Exceeding expectations: We shine, stand out. We're proud.
1. On target: Everything is going well. We're satisfied.
-1. Off target: If we're not performing well.
-2. Failing: If we are falling short, not honoring agreements.
-3. Embarrassing. We're suffering reputation damage, profound shame.

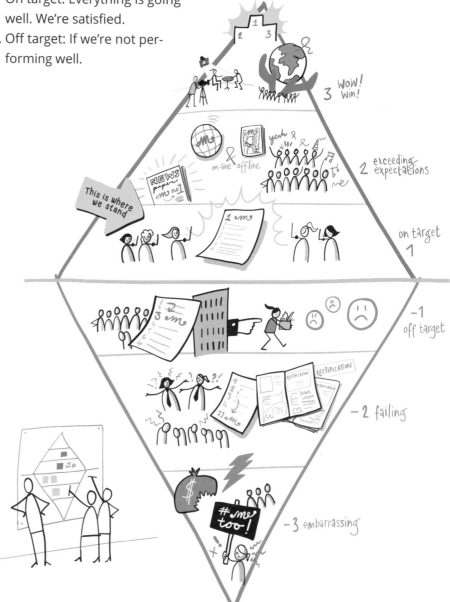

RETROSPECTIVE

Retrospectives can be dull and repetitive. Liven things up by getting visual. Try all sorts of templates to see what works for your team.

Draw a timeline that represents the sprint, with a happy face above the line, and a sad one below. Categorize and color code post-its you use to fill in the template and invite your team to write down key moments or situations and to place them on the timeline.

Discuss their input. Alternatively, draw a circle divided into five and ask people to provide input on five topics regarding the team's performance in its last sprint.

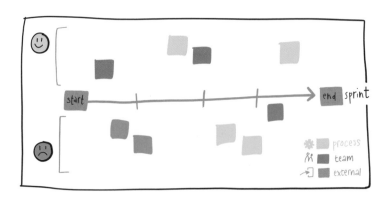

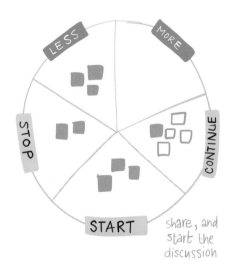

TEAM TEMPERATURE

Take the group's temperature – either at the start of a meeting to get insights into the group's needs, or at the end to get feedback.

You can do this with a variation of an empathy map, or using other creative comparison techniques (Visual Thinking, p.98). For example, one of our colleagues once built a miniature traffic light to let us know how she was feeling.

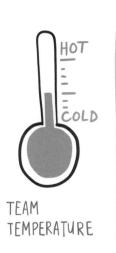

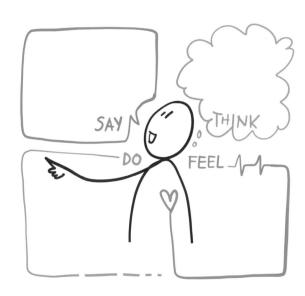

5.6 TEAM VISION POSTER

When you've formulated a vision with your team or organization, you can work together to visualize it in a poster. Place it somewhere visible and use it as a reminder, inspiration and trigger to keep taking action to achieve your goal. The poster is also a simple way of communicating your vision outside of your team, or could serve as a sketch for a professional graphic.

Warm-up
Start the process with an introduction and optional warming up exercise from chapter 5.1. You can discuss the team's alignment on the vision, but you can also try starting without this input!

Dream out loud!
Create visuals and metaphors by daydreaming out loud. Close your eyes and get the group thinking. You could tell them: "We are five years down the line; our vision has become reality. You wake up in your bed at home. What noises can you hear? What woke you up? What thoughts run through your mind as you wake up? You're getting ready to go to work. What is the first thing you do? What is your morning routine? You go to work. Where do you go? Do you need to go somewhere else on your way? What does the rest of your day look like? Do you have appointments with other people? Who do you meet? What do you see at work? How do you feel during the day? Are there things that make you proud? What conversations do you have?

At the end of the day you go home, or you were already at home. What do you do? What do you think if you look back on the day?"

Ask the group to note down images, words and important moments of the day on cards or post-its. Make pairs and share how you experienced the day. Ask questions to generate more (specific) images. Finally, stick these elements on a card or whiteboard.

USE THIS WHEN:
- Team building is important
- You want to create one, shared vision to work towards
- You want to communicate your vision to the outside world

If necessary, you can write down a few words to clarify each image.

Interview
Other people, such as stakeholders, could be involved in reaching your vision. You can interview them to see if they can produce images to add to your board and ask them about their situation once you have achieved the vision.

Use sensory questions such as:
- How does it look to you if …?
- How do you feel if …?
- What's it like for you if …?
- What can you hear people saying if …?
- What do you say if …?
- What do you think if …?

Add the responses to the cards or post-its you've already made.

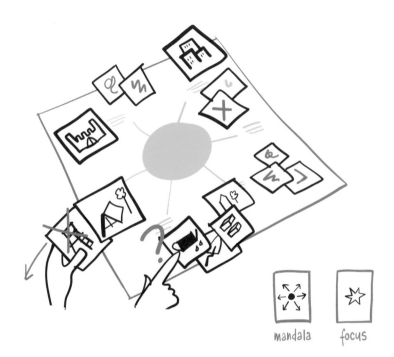

Visualize

See section 2.7 'How to make a visual' on how to approach making a visual.

mandala focus

The interviews will give you all the elements that could end up on your poster. If you have too many, you may need to select some and eliminate the rest. Look back to section 5.4 'Select and Eliminate' for tips on how to deal with this.

Other elements that could be included are:

- Who or what is this vision for?
- What is the vision?
- Other themes linked to the vision such as stakeholders, customers, environment or society
- Optional elements to enrich or clarify the image such as the underlying mission, value added elements, historical or contextual information.

Choose a visual plan. The best type of plans for this type of poster are the mandala or focus. Think of a metaphor (or use the sun, an icon frequently used to represent vision) and make a composition sketch.

Plot all elements on your composition. Use a big sheet of (brown) paper for this! Take turns placing your visual elements on the composition (in such a way that they can be moved later). Once you've agreed on the composition and content, do a final check:

 Is your story clear?
 What images can we remove and what is still missing?
Does the poster make us happy?

Optionally, you can draw a cleaned-up version of the poster or hire a professional to do this for you.

Tip: Make sure it is clear that the poster is depicting a vision. And don't try to squeeze in too much information.

Tip: If you want to reinforce the poster, leave space at the bottom where management can sign it or leave a supporting message.

5.7 ROADMAP

If you have a clear idea about the goals, vision or aim of a project or team, it can be extremely useful to visualize the path toward this objective.

The term Roadmap is pretty familiar in business settings, and we are here to help you create your team's distinctive (visual) roadmap. By co-creating a roadmap, you give all stakeholders the opportunity to provide input. Working together on a mutually agreed path can prevent future conflicts and you will get the best results in an energetic, efficient and fun way.

To see how to create a (roadmap) visual together, see section 2.7 'How to make a visual'.

Roadmap plan
A roadmap has a clear chronological order. With that in mind, the visual's underlying plan will presumably be a sum, a timeline or a road.

Choose the layout and structure that best suit the needs of your team and stakeholders: Use perspective to really draw people into the roadmap.

Roadmap metaphor
Use a metaphor within the roadmap that is meaningful for the stakeholders: A straight road through a desert, a river in mountains, stepping stones in a wild river …

Tips: Supersize it!

Get help from a facilitator to make sure you ask and answer all the right questions and not only the easy ones.

Put the roadmap somewhere where everybody can see it (this could be on a prominent wall, but also digital, on an intranet page) and keep track of progress.

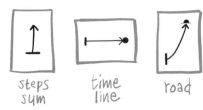

steps sum time line road

USE THIS WHEN:
- You'd like to set goals and make a plan
- You want to have a visual reference of what you are doing and where you are in a process

Roadmap elements
Most roadmaps contain these (or a few of these) elements:

1. End point/aim/goals/vision
2. Reason for embarking on this path (mission, urgency of the project)
3. Trends/external influences
4. The path itself (road, stream, stepping stones… whatever metaphors you choose)
5. Timescale; dates or phases
6. Themes that influence the journey such as marketing, operations and culture. Or more sharply focussed: online/offline marketing, content marketing
7. Audiences and stakeholders
8. Opportunities, choices to be made
9. Obstacles and challenges along the way
10. Unknown variables and how they could happen and influence the journey
11. Space to track progress
12. Measurability

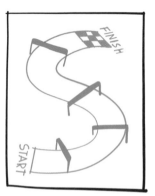

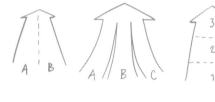

TRENDS

STAKEHOLDERS

HOW

STEP 1

5.8 AS-IS AND TO-BE PERSONAS

This is a visual exercise that fosters a better understanding of strategies and how people relate to them. Participants in this session use visuals to express and share their own experiences. If the image is clear and captivating, everybody will be able to communicate its message. This brings a strategy to life.

Visualize two personas. The first is an AS-IS (who are you now, what does it mean to be this way). The second one is the TO-BE persona (who do you want to become, what does it yield). These are group or company-wide personas, so do not take it personally.

AS-IS persona

Everybody needs to be able to share their feelings about the current organization. When you want to make a change, you have to agree on the 'now' and the desired change of direction.

Ask everyone to draw the current organization in the form of a persona. Some inspirational questions could be:

a. What does the organization/persona do – what's it carrying in its hands?

USE THIS WHEN:

- You want to get insight in the way people feel
- You want to share who you want to be/where you want to go
- You want to change the way people work or interact

b. What is the organization/persona thinking about – what's in its head?

c. Who is the organization/persona in contact with – who are the other people surrounding it?

d. What is the organization/persona's personality – is it cautious, innovative, traditional?

e. What are the organization/persona's values – what's in its heart?

f. What is the organization/persona looking forward to – what's its definition of success, future perspectives?

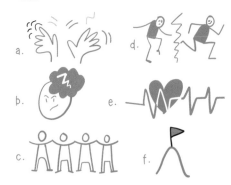

Split up into small groups to come up with a new, collective AS-IS persona, drawn on an A3 sheet of paper. When they're finished, stick them on a wall. One by one, analyze each drawing (without the makers' input or explanation).

What images do you see? What do you think of the organization as it looks now? Try to spot similarities.

The designated drawer (preferably an outsider) listens to the discussion and draws a big, new persona combining the input. Get the group's feedback so the final image reflects everybody's opinion.

Finally, give the AS-IS persona a name or title, e.g. 'rushed juggler' or 'happily naive'.

TO-BE persona

A company's strategy can often be quite abstract and doesn't go into detail about the 'how' or 'what'. This leaves room to define your own team's ambition and preferred persona within the broader strategic goal.

To define this persona, hold interviews in groups of three: One person interviews, another is interviewed and the third notes the answers and fills them in on the template provided. Take turns and ask each other about goals, image and behavior. This shouldn't take longer than 10 minutes.

Make a big template where you bundle every group's key answers.

From there, the 'designated drawer' can create a big, collective TO-BE persona (listening carefully to the group's choices about which answers should go on the big template and which should not).

You could also divide the group into smaller groups again and let them visualize a TO-BE persona of their own. Share the outcome with the whole group and discuss, while someone combines it all into a final, collective TO-BE persona.

Name the persona and hang it up next to the AS-IS persona. Does everybody agree with the outcome? After a break, or in a next session, you can define next steps: What can we do NOW to get one step closer to our TO-BE persona?

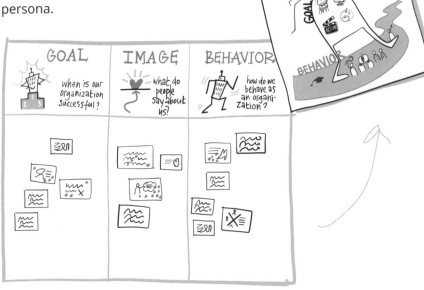

Tip: Use dot-voting stickers to reach a democratic top 3 for example.

the ripple effect of visual thinking

6. DAY-TO-DAY BUSINESS: US

Finally, let's take a look at how these tools and (visual) sessions can work together and really make a positive difference to an organization.

We want to highlight four different cases we have worked on. As we discuss these cases, we will refer back to visual work forms that you read about in chapters 4 (ME) and 5 (WE). As you read about our cases, feel free to flick back to those chapters to refresh your memory.

6.1 CHANGE OF BEHAVIOR

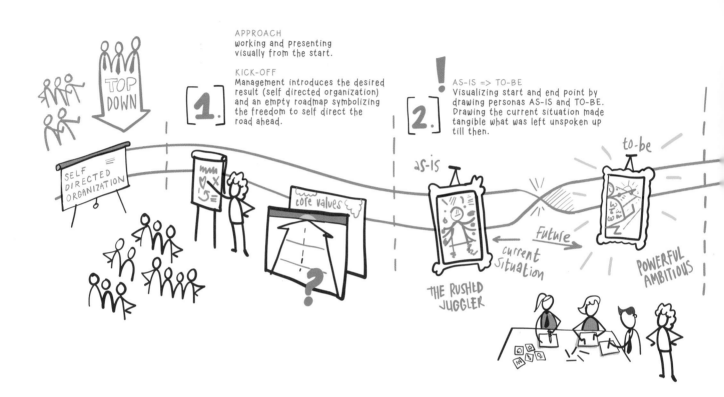

APPROACH
working and presenting visually from the start.

KICK-OFF
Management introduces the desired result (self directed organization) and an empty roadmap symbolizing the freedom to self direct the road ahead.

1.

TOP DOWN

SELF DIRECTED ORGANIZATION

core values

?

AS-IS => TO-BE
Visualizing start and end point by drawing personas AS-IS and TO-BE. Drawing the current situation made tangible what was left unspoken up till then.

2.

as-is

to-be

Future

current situation

THE RUSHED JUGGLER

POWERFUL AMBITIOUS

Situation
A healthcare company with 2000 employees (1100 of whom are volunteers) was trying to implement a new, self-directed way of working. Its strategy was traditionally communicated top-down, and focused mainly on targets set by the management. While attempting to change this, new insights came into focus about the existing company culture. Bureaucracy, fear of failure and competitive behavior all stood in the way of the intended change.

Goal
Management had an ambition for company-wide change. In line with the desired way of working, they wanted teams and employees to set their own path and plan toward this ambition. To achieve this, they needed to change the company culture. This meant a shift from busy, guarded employees to a powerful, open and ambitious staff. We used drawing to map out the path, clear tensions and investigate blockages in a neutral, fun and creative way.

Result
Our program increased employee engagement. It clarified the new shared ambition and helped formulate goals and paths to reach it. The process energized workers and made them eager and open to become more self-directed.

TOOLS USED IN THIS CASE:

- As-is and to-be sessions (we)
- Collect and structurize input (we)
- Roadmap (we)

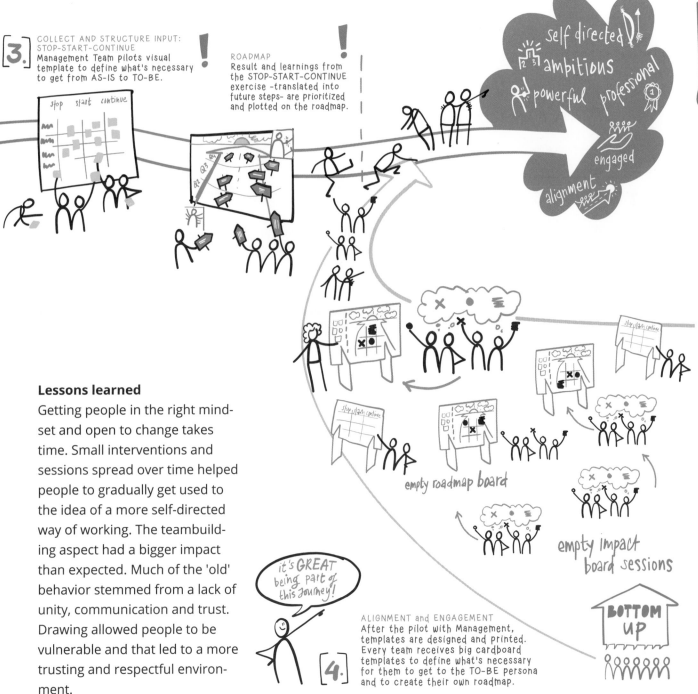

3. COLLECT AND STRUCTURE INPUT: STOP-START-CONTINUE
Management Team pilots visual template to define what's necessary to get from AS-IS to TO-BE.

ROADMAP
Result and learnings from the STOP-START-CONTINUE exercise –translated into future steps– are prioritized and plotted on the roadmap.

self directed
ambitions
powerful professional
engaged
alignment

US

empty roadmap board

empty impact board sessions

BOTTOM UP

it's GREAT being part of this journey!

4. ALIGNMENT and ENGAGEMENT
After the pilot with Management, templates are designed and printed. Every team receives big cardboard templates to define what's necessary for them to get to the TO-BE persona and to create their own roadmap.

Lessons learned

Getting people in the right mindset and open to change takes time. Small interventions and sessions spread over time helped people to gradually get used to the idea of a more self-directed way of working. The teambuilding aspect had a bigger impact than expected. Much of the 'old' behavior stemmed from a lack of unity, communication and trust. Drawing allowed people to be vulnerable and that led to a more trusting and respectful environment.

6.2 MAKING PLANS

TOOLS USED IN THIS CASE:
- Heart-to-heart conversation (me)
- Select and eliminate (we)
- Team evaluation (we)

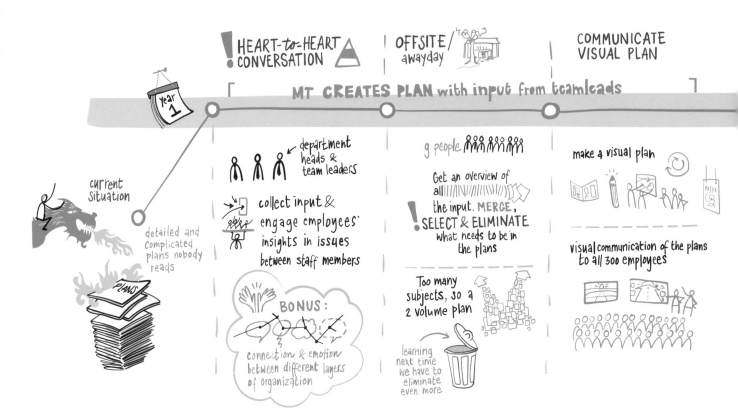

Situation

This entertainment company dreaded making plans, but made them anyway. It took up valuable time, energy and effort and when they were finished people forgot the plans or didn't have time to look at them. Management would have preferred employees to take ownership of the planning process, but didn't think their hard-working staff could free up the necessary time.

Goal

To create a recurring, energetic planning process in which employees feel involved and connected with the plans that it generates, or even make their own plans.

Result

Engaged employees and an energetic process. There's a defined visual methodology consisting of a set of visual templates for having heart-to-heart conversations and creating plans in a fun, efficient and visual way. There is a human aspect to it that ensures connection and interaction between different layers of the organization. The process can be improved and refined in the coming years.

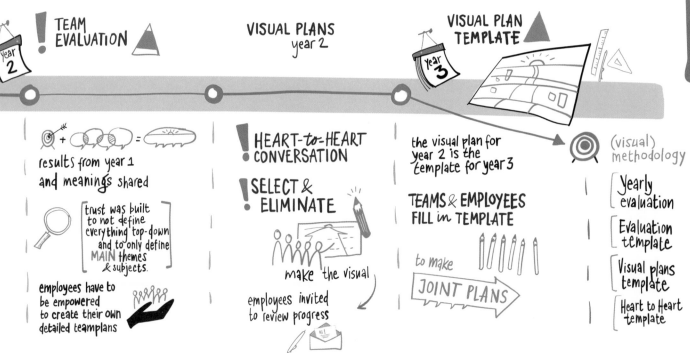

TEAM EVALUATION — Year 2

VISUAL PLANS year 2

VISUAL PLAN TEMPLATE — Year 3

results from year 1 and meanings shared

trust was built to not define everything top-down and to only define MAIN themes & subjects.

employees have to be empowered to create their own detailed teamplans

! HEART-to-HEART CONVERSATION

! SELECT & ELIMINATE

make the visual

employees invited to review progress

the visual plan for year 2 is the template for year 3

TEAMS & EMPLOYEES FILL in TEMPLATE

to make JOINT PLANS

(visual) methodology

- Yearly evaluation
- Evaluation template
- Visual plans template
- Heart to Heart template

Lessons learned

1. Plans are made even lower in the 'pyramid'. An interesting lesson that emerged was that visualizing a plan enhances employee engagement; getting employees to fill in a visual template led to them actually taking ownership of the plans. This means management has to trust people to take this ownership.

2. Discussing both business and personal topics (heart-to-heart conversation) with a visual template at its core, ensures that plans are well balanced between business goals and employee wellbeing.

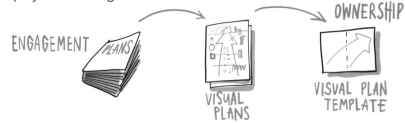

ENGAGEMENT → VISUAL PLANS → OWNERSHIP VISUAL PLAN TEMPLATE

6.3 UNDERSTANDING THE STRATEGY

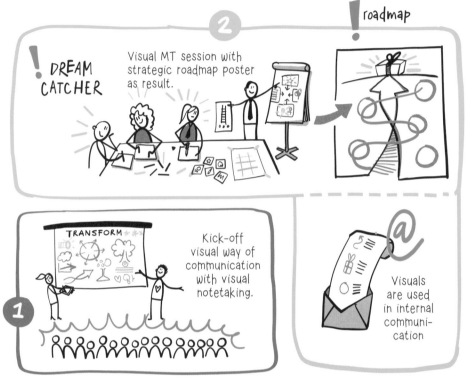

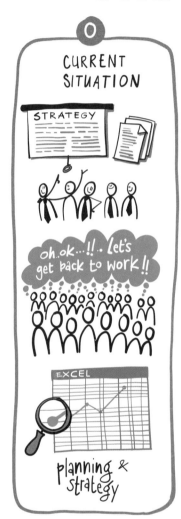

Situation

A pharmaceutical organization's management team spent a lot of time each year creating strategic plans in Excel sheets. Business was going very well, but the political and economic climate is changing; new and strong competitors are emerging. It is time for change!

Employees got used to the data-driven strategic presentations. Afterwards they return to business as usual. Nothing changed.

Goal

- Drive change by inspiring people, using more than just facts and figures.
- Unplug employees from their daily grind, raise their awareness of the need to transform the way they're working.
- Clarify the strategy to increase employee engagement.

Important: Communicate in a positive way (since their hard work so far has paid off in great results). That's why we work visually!

TOOLS USED IN THIS CASE:

- Roadmap (we)
- Team vision poster (we)
- Dream catcher (we)
- Abstract drawing (we)

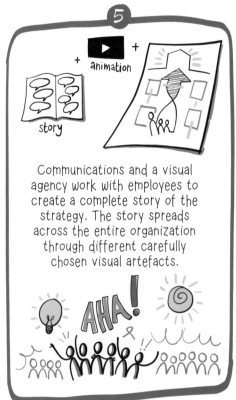

Communications and a visual agency work with employees to create a complete story of the strategy. The story spreads across the entire organization through different carefully chosen visual artefacts.

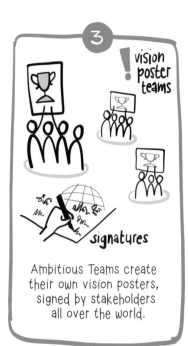

Ambitious Teams create their own vision posters, signed by stakeholders all over the world.

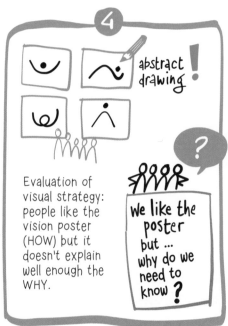

Evaluation of visual strategy: people like the vision poster (HOW) but it doesn't explain well enough the WHY.

Result

In two years' time, strategic communication created by a few, presented in complex Excel sheets and text-heavy Powerpoint slides was transformed into a simple yet meaningful visual story created by many. An employee said during the presentation of the visual story "...this feels like finally the sun is breaking through. Now I know why I am here, where we are going and what I have to do to make a change."

Lessons learned

The most important lesson we learned from this process is that an image can change the way people look at and understand strategic topics. But the image alone will not change the way people work. To actually make a change, employees need to understand and be energized by the entire story. They need to be able to recognize themselves in it.

What we need to achieve this: Co-creation, fun, patience and visual courage.

6.4 CHANGING AN ORGANIZATION

IN THIS CASE:
- How to present yourself (me)
- Visual note-taking (me)
- Organizing visually (me)
- Visual Problem Solving (me)
- Me in the bigger picture (me)

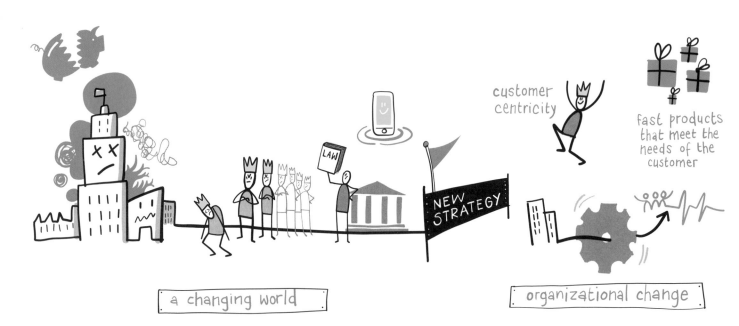

a changing world

organizational change

customer centricity

fast products that meet the needs of the customer

LAW

NEW STRATEGY

Situation

In 2012 the banking crisis was nearly over. But it had created a new reality. Many people had lost trust in banks and the financial sector had to respond to new demands from regulators and markets. The increasing importance of the smartphone was (and still is) reshaping the industry. It was time to recalibrate strategy, organization and products.

Goal

In this rapidly changing world, banks have to become way more tech-savvy and customer-oriented. To meet the ever-shifting demands of the world around them, the whole organization had to change; become agile and able to respond fast to change. Visual thinking was an important tactic to bring about this change and as a bonus people becoming more creative.

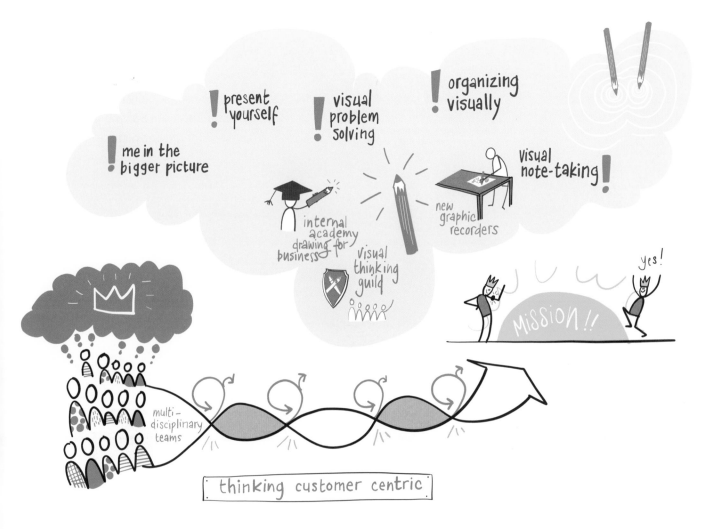

Result

<mark>A new way of working</mark> was implemented, but this also must be seen as a new beginning in which much still needs to be learned. Working visually literally made these changes visible (by seeing the change/visuals all around you). It created a culture with more passionate, motivated, self-directive employees.

Lessons learned

Visualizing changes clearly helps employees learn to work in an agile way and to use visual skills for communication. A visual way of working is becoming more and more part of day-to-day business. Ideas and plans get shared more easily, communication is accelerated and misconceptions are resolved faster.

Share the drawing
and re-use it

WORKING
visually starts
with YOU!!

visual meetings

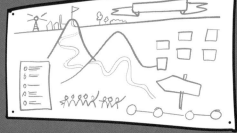
the big picture

posters
[canteens,
entries,
halls & elevators]

Visual
documentation

explanatory
animations

visual process

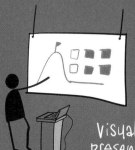
Visual
presentation

re-use digitally

Visual
note-taking

7. KEEP ON DRAWING AND DOING

The more you practice the better you get. Rome wasn't built in a day.

Challenge yourself to practise for a wider audience, and be confident when you draw with and for your team. Inspire people to pick up their own pens and pencils and experience the power of visuals together.

If you are able to use fewer words and more visuals you are doing great. When you start drawing at work you might develop a joint visual vocabulary which is great and fun. Project icons can be used over and over again and metaphors for projects could emerge. Hang your posters on the wall and inspire people to work visually; it starts with you!

We hope this book has inspired you (again) to embrace the power of visual thinking and encouraged you to be a visual ambassador.

Don't do it alone. At some companies we've worked with, people have formed Visual Thinking communities or guilds. This fills us with joy: The visual ball is rolling!

At our label BRAND Business (part of Buro BRAND) we embrace and encourage change by means of visual collaboration. With a great team of Visual Thinkers, designers, illustrators and consultants we are happy to make this Visual Revolution happen.

Let's keep on doing visual!

7.1 TIPS

Sticky notes

Don't try to archive all those sticky notes. There are apps (such as Post-it Plus) that allow you to rearrange, edit and copy text after taking a picture.

Use multiple colors sticky notes, to add an extra layer of meaning. E.g. blue sticky notes for bottle-necks, green ones for ideas.

When drawing on sticky notes, do it with a marker instead of a pen, use a dark color and make any letters all caps. It makes them easier to read.

Move your sticky notes. Think of moving animations and transitions in Powerpoint. You can do this in an analogue way.

Capture and share

Take a photo of (a part of) a drawing and use it in Powerpoint, Word, on social media, in a news-letter, email, you name it!

Engagement increases as the story is picked up by colleagues or team members. The story itself will stay the same but everyone can use their own words to explain it.

A great way to share is by starting a visual guild within the compa-ny. Organize meet-ups, inspiring speakers or just business drawing workshops.

Google is your friend

Remember, GOOGLE Images is your friend. It is a great resource for searching different key-words and making visual combinations for real visual story telling.

 www.thenounproject.com
www.iconfinder.com

You can make it even easier by typing the word 'icon', or 'vector' or 'illustration' after your search term. You will get simplified icons that are easy to combine or copy.

IꟽPERFECTION ~~I~~ *Sticks* !!

pptx

Dare to draw!

Don't forget we draw to communicate or to get a message across. So don't be too hard on yourself. Your drawing is fine as it is. Just keep at it and you'll get better and better. It feels more natural to draw with each and every drawing you make.

Digital

At color.adobe.com you can create your own color schemes. Change the 'Color Harmony' (to Triad or Complementary for example), pick a color in the wheel and let the tool compile a scheme. You can also explore and search schemes made by the community.

Analogue and digital can be complementary. Of course you can take a picture of your analogue presentations and then spread it further digitally, or draw something from your Powerpoint.

Have everybody design their own avatar. Use it when tasks are distributed to keep track of who does what.

SketchBook Paper Adobe Draw

Procreate Sketches

You can easily draw digitally on a tablet. We love to illustrate on our iPads. For tips on apps, check out our website. There, you can see what apps we use to draw, photograph and get some visual icon inspiration.

A great way to keep practising your visual skills is by playing games like Hints or Pictionary! You will get used to drawing under time pressure and have fun at the same time.

iFontMaker

If you like working digitally on your tablet, try the app iFontmaker. It lets you digitalize your own handwriting so you can use it on other digital platforms.

That's how we made this typography

#VISUALCOLLABORATION
#VISUALTHINKING
#VISUALSTORYTELLING

7.2 ABOUT THE AUTHOR
WILLEMIEN BRAND

unlocking your creative potential. let's start this #visual revolution together

Willemien Brand has turned her passion for drawing and design into her life's work. She graduated with distinction from the prestigious Design Academy Eindhoven and enjoyed an award-winning career as an industrial designer before setting up the successful visual communication company Buro BRAND with its labels Studio BRAND, BRAND Academy and BRAND Business.

The longer she worked in design, the clearer it became to Willemien that drawing and visual thinking are powerful tools that can break down complex problems, engage employees and build bridges between businesses and their customers.

She never goes anywhere without a pen. Eating out with family and friends, a restaurant's paper tablecloth becomes her canvas as she doodles to explain ideas or draw a summary of the night out.

Now she shares this passion with people and companies throughout the world as one of the leading figures in the visual communication revolution.

7.3 WITH ESSENTIAL INPUT FROM
HESTER NAAKTGEBOREN

Embrace your imperfections, everybody can draw! #namaste

As Buro BRAND's Art Director and designer Hester started noticing the big impact drawings can make on people and teams. What a joy that incomprehensible information can be captured in understandable, simple and fun visuals!

With a background in communication and design, Hester is on a mission to save people from the ordeal of decoding vague Excel sheets or wading through piles of official documents.

As a trainer and graphic recorder she loves to study group dynamics and use this while drawing. Sketching out what has been said, but also what has not been said. Those unspoken words can be a tangible and powerful presence in a room.

Hester believes everyone is creative in his or her own way. Let go of your fear of imperfection and enjoy the power and fun of visual thinking and doing.

GEORGETTE PARS

"if people would talk less, that'd be great"

As program manager at Buro RBAND, certified Scrum Master and professional Visual Thinker with a background in design, Georgette helps people and organizations find structure and focus so new ideas can emerge.

Since she was young, Georgette has always had an interest in how people communicate and a keen eye for contradictions and misunderstandings. It's hard to convey a crystal clear, unambiguous message using only words. In business settings, where communication is vital, it is such an important skill to be able to grab a pen and support your story with visuals!

With her crititcal thinking, analytical mind and wide interests, she likes to get to the bottom of things and make the world a better place. Somehow. Someday.

INGE DE FLUITER

Visual Doing does not require any talent for drawing. you only need to ignite your creative courage! #letsgetvisual

Inge's mission is to fan creative courage, joy and passion in people's lives and working environments. With a background in marketing and management she uses the power of sketching to coach teams to see the bigger picture, to live their mission and to realize their vision.

She has been sketching and doodling all her life. Drawing enables her to make explicit what is going on in her head and heart, and to make sense of what is happening in the world around her.
It sparks her imagination; reveals patterns and paths that she can share with others.

Visual doing brings her an intrinsic sense of direction. It has led her to inspiring jobs, places and – above all - people.

LAUT ROSENBAUM

Laut is an art teacher and strategic creative who loves confronting complex challenges.

Through his strategic creative work, he consults and inspires companies, organizations, agencies and human beings who are curious to explore a more visual way of communicating concepts and ideas. Using pen, paper and a lot of inspiration, Laut turns fuzzy concepts into clear ideas by using visuals to make them tangible. He is a specialist in framing and finding solutions to challenges, and in co- creating visual and written stories that resonate in people's minds.

As Concept Development and Visualization teacher at the Royal Academy of Art and drill sergeant at the School of Young Talent, Laut challenges gifted students to explore new ways to work, ponder and play. And as the Business Drawing and Visual Storytelling Trainer at Buro BRAND, he teaches people how to harvest the power of visual thinking and doing.

7.4 HOW THIS BOOK WAS DONE

The creation of this book could not have been possible without the help of so many people!

All illustrations in this book were done on a 12,9-inch iPad Pro with an Apple Pencil.
We used the Adobe Illustrator Draw app, in this way the sketch appeared immediately after uploading on the iMac desktop Adobe Illustrator CC application. Portraits we made in the Adobe Photoshop Sketch app.

In addition to Willemiens own handwriting we used the following fonts:

Montserrat
Helveticamazing
Open Sans
American typewriter
buroBRANDhandwriting

VISUAL THINKING

If your business hasn't already embraced visual thinking, why not?

Visual thinking and drawing are both becoming increasingly important in today's business settings. A picture really can tell a thousand words. Visualization is a crucial part of the journey for companies seeking to boost enterprise agility, break down silos and increase employee and customer engagement. With the right mindset and the simple skills this book provides you the skills to develop your own signature and style and start generating change by integrating visual communication into your business setting.

VISUAL THINKING & DOING
WORKBOOKS

The Visual Thinking and Visual Doing workbooks are great tools to help you kick-start your visual journey and gain confidence to produce amazing compelling drawings.

Crammed with tons of visual exercises, ranging from tracing illustrations to drawing hacks. These workbooks will inspire you to design and share your own icons! (really it will!)